CONTENTS

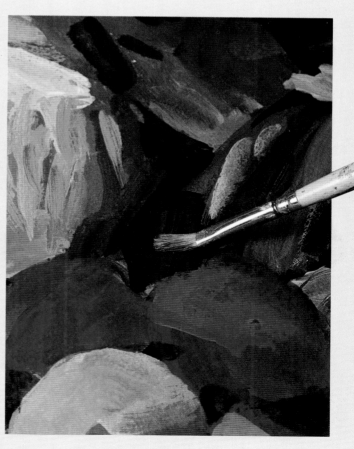

A most versatile medium

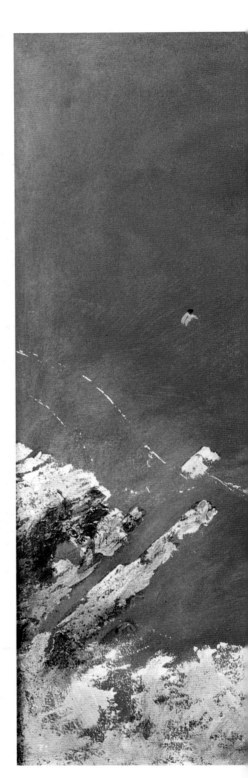

ACRYLIC IS a new, exciting and incredibly flexible painting medium. It first became commercially available in the 1950s – compare that with the 500 years we've had to get to know oil paint. Its outstanding characteristics are the speed with which it dries, the great range of supports it can be used on and the almost infinite range of techniques and effects that can be achieved.

Acrylic is marvellous for beginners because its quick drying time allows you to build up layers of glazes, washes and scumbles, each of which would take ages to dry using oil paint. And if you make a mistake or change your mind, you can overpaint and start again. Use it for thin watercolour washes, for rich, thick impastos, for collage, for airbrushing, or for line and wash.

It has many practical advantages. It doesn't smell, the basic materials are simple, and because it mixes with water, it is easy to wash brushes and utensils. The fact that it dries so quickly means that you don't have to wait ages before a painting is ready to be put away – important if you have to clear up after every session because you don't have a dedicated painting area.

BEGINNER'S GUIDES

PAINTING IN

Acrylics

PATRICIA MONAHAN

STUDIO
VISTA

ACKNOWLEDGEMENTS

The author and publishers would like to thank the following artists who have allowed us to use their work in this book: John Crawford Fraser, pp. 4–5, 6, 7, 89; Ian Sidaway, pp. 8–9; Stan Smith, pp. 6; Richard Tratt, p. 57.

Special thanks are also due to Winsor & Newton for generous help with materials; to Winsor & Newton and Mr Rogerson of Spectrum Oil Colours for technical advice; to Ian Sidaway for step-by-step demonstrations and the projects on pp. 52–5 and 78–81; to Stan Smith for the projects on pp. 58–65, 66–9, 82–7; to John Crawford Fraser for the projects on pp. 70–7, 90–5; and to Fred Munden for taking the photographs.

Studio Vista
an imprint of
Cassell
Villiers House
41/47 Strand
London WC2N 5JE

First published 1993

British Library Cataloguing-in-Publication Data
A catalogue record for this book is available from the British Library.

ISBN 0-289-80072-2

Series editors: Jenny Rodwell and Patricia Monahan
The moral rights of the author have been asserted

Distributed in the United States by
Sterling Publishing Co. Inc.
387 Park Avenue South, New York, NY 10016-8810

Typeset in Great Britain by Litho Link Ltd.
Printed in Great Britain by Bath Colourbooks.

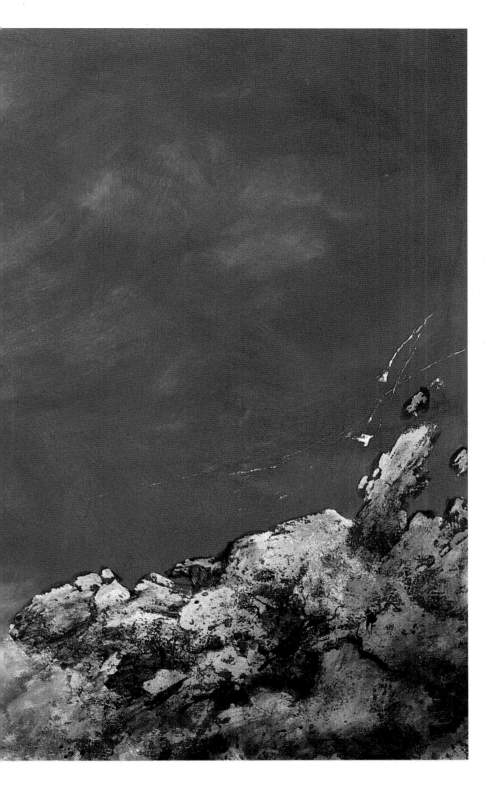

◁*In this simple but dramatic painting, John Crawford Fraser sets a large area of intense cobalt-blue sea against textured and delicately coloured rocks. It would be difficult to achieve such a depth of brilliant colour with any other medium. The blue is brushed on thinly, so that the canvas gleams through in places, creating the lights and darks of the eddies and currents in the water. The rocky area at the bottom of the picture was built up using texture paste, which was then glazed with transparent colour.*

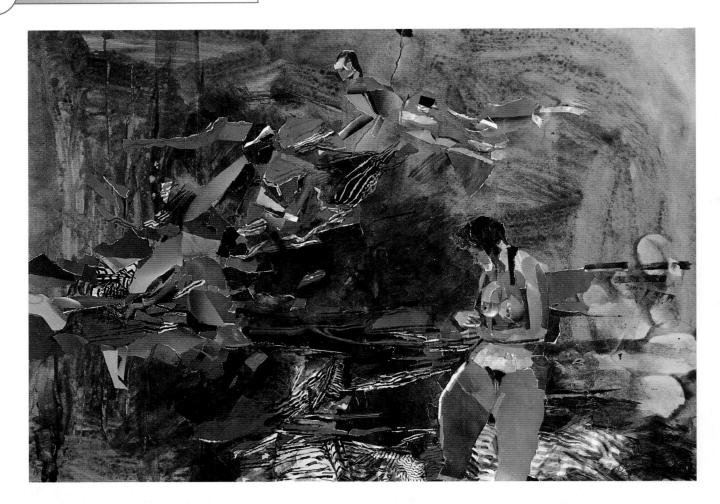

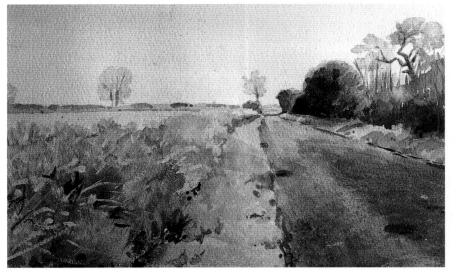

△ *For this moody study of figures in a pool, Stan Smith used thinly diluted acrylic paint for the background, flooding it on to the paper like a watercolour wash. He added texture with a variety of media, including ink, gouache and acrylic. The collaged figures were then pasted on using acrylic medium and paint.*

△ *This 'watercolour' by John Crawford Fraser is actually acrylic. The artist finds the rapid drying time useful when working out of doors. Opaque creamy-white paint has been used to add texture and emphasis to the vegetation on the left of the picture.*

▷ *In this sea study John Crawford Fraser combines thin washes of colour which allow the texture of the canvas to show through with thick swathes of opaque colour applied with a knife. This painting illustrates the flexibility of the medium and makes an interesting contrast to the work on paper by the same artist.*

A water-based medium

Although acrylic can be 'mixed' with water, it is not 'soluble' in water. So while water can be used to thin or extend the paint, and to wash brushes and painting equipment, once the paint film is dry it is entirely waterproof.

Acrylic is very simple to use – no need for messy jars and bottles of oils and pungent turpentine. This is particularly appreciated by artists who find the smell of turpentine unpleasant; some people are actually allergic to it.

Fast-drying

Acrylic dries quickly. A wash of acrylic on absorbent paper will dry instantly, thin colour on primed canvas will dry in minutes and a heavy impasto will dry in less than a day; a similar oil impasto might take months or even years to dry completely.

If you have a slow, meticulous technique which depends on working into a wet surface and carefully blending colours and softening edges, you may find that acrylic paint dries far too quickly. If this is the case, you can add a retarding medium – this, as the name suggests, slows the rate at which the paint dries – or you can spray the picture surface with water as you work. If you really find the rate at which it dries a problem, you might be best to stick with oil, which gives you plenty of time to manipulate the paint surface, keeping acrylic for quick sketches or underpaintings.

Working oil over acrylic

Oil paint can be painted over acrylic once it is dry. However, acrylic should not be painted over oil, as the oil in the oil paint repels the water in the acrylic paint.

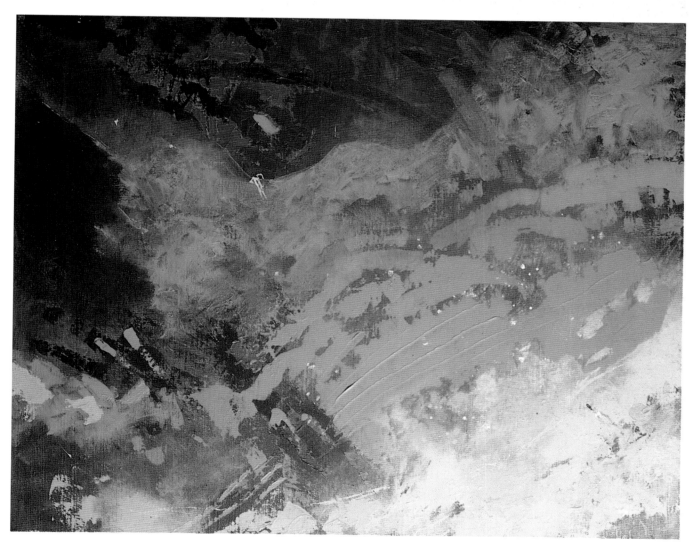

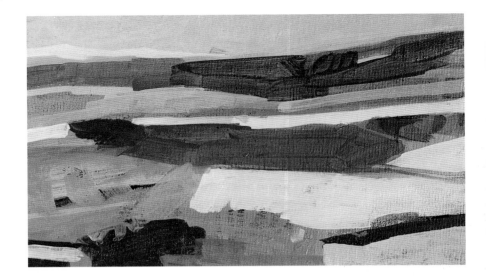

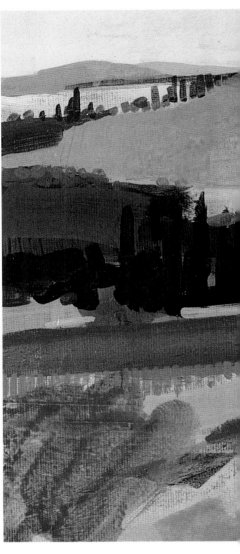

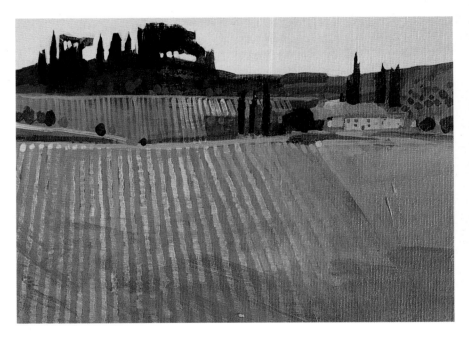

Using acrylic for an underpainting allows you to block in the composition extremely fast, using oil and the traditional oil techniques for the final layers. You could, for example, begin a landscape painting out of doors, using the simple equipment necessary for acrylic work – the paints themselves, a brush, a support and a pot of water. The painting could then be completed at a more leisurely pace in the studio, using oil.

A variety of supports

Acrylic can be used on almost any non-greasy surface which has enough tooth to hold the paint – paper, cardboard, hardboard, wood, canvas, metal,

even a brick wall. Unlike oil, the paint film does not have to be isolated from the fabric support, so it can be used for staining techniques, in which liquid paint is applied directly to the raw canvas to create exciting passages of luminous colour. When dry, acrylic is tough, flexible and virtually indestructible, and unlike many other paint vehicles it does not discolour or become brittle with age.

A range of techniques

Acrylic can be used for almost all of the techniques available to the artist in oil or watercolour – for thin watercolour washes as well as for thick, juicy impastos. But it is a shame to think of acrylic as simply a

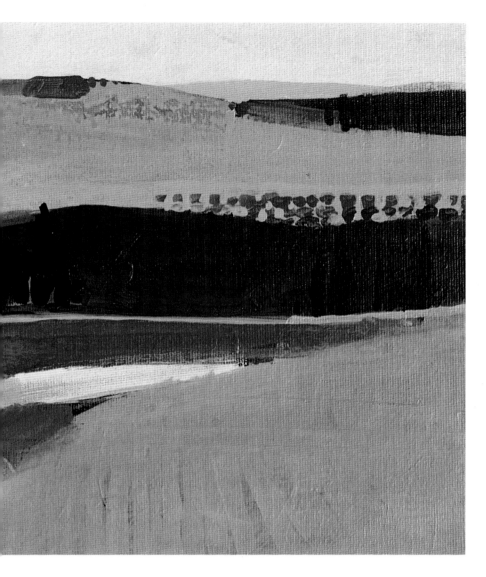

◁ *In these studies Ian Sidaway was investigating the compositional possibilities of the Tuscan landscape. He often uses a series of studies to develop ideas for his larger works. He worked from photographs, sketches and memories of the area, and chose acrylic paint because it allowed him to put down his ideas quickly, overworking layers of colour on one picture, then moving on to another. The pictures are small, about 12 × 10 inches (30 × 25 cm), and are painted over old canvas boards – you can see the darker passages of colour showing through in parts. Two of the studies are worked very loosely, the others are tighter. The artist used matt medium with the acrylic colour to extend the paint and give it a flat, non-glossy finish, reminiscent of gouache or egg tempera. The ochry-green palette and flat colour reflect the hot, dry earth colours of Tuscany.*

substitute for either, as it will usually fall short of the 'real' thing in some way.

The alleged 'disadvantages' of acrylic are most apparent to experienced painters who have grown up with other media. It suffers most, and very unfairly, when compared with oil paint. Artists who trained with oil paint automatically compare the new medium with the old, using acrylic with oil techniques, and constantly find it wanting. 'It dries too quickly', 'It doesn't feel the same', 'It doesn't look the same', and so on. But this misses the point – acrylic isn't the same.

Absolute beginners get more from acrylic because they have no prejudices or preconceptions and so use the medium for what it is, rather than for its ability to ape other media. Get to know acrylic, experiment with different supports, techniques and the host of media. You'll find it is great fun.

Mixed media

One of the most exciting applications of acrylic is in mixed-media techniques. Because the paint film is non-soluble once dry, you can work over it in other media – in pencil, pastel, oils and crayon, for example. And because acrylic is such an effective adhesive, it is ideal for collage – you can glue almost any material to the support, using paint or one of the media. If you want to include heavy materials like card or coarse fabrics, you should use one of the stronger adhesives like texture paste.

Materials

*T*HE BASIC materials required for an acrylic painting are very simple – a brush, some paints, a palette and a piece of paper or canvas. Acrylic is marvellous for anyone starting to paint because it allows you to get going quickly and for very little outlay.

But that isn't the end of it, for one of the joys of the medium is the opportunity it provides for experimentation with techniques, effects and materials. You can, for example, paint directly on to all the traditional supports, such as paper, canvas and board. You can also paint on to other surfaces, such as walls, ceramic, metal or glass – almost anything as long as it is non-oily and has a little tooth to hold the paint film. You can have enormous fun exploring the qualities of different supports, using the paint directly on absorbent surfaces, or sealing the surface to make it non-absorbent. The effects of these qualities can be exploited in your work.

Acrylic paint can be used directly from the tube or thinned with water. But the real fun starts when you begin to add media. The range is huge: there are matting agents, glossing agents, pastes which allow you to work almost in three dimensions, extenders, retarders and strange concoctions with distressingly chemical names – but they work. So have a go!

△ The basic materials for painting in acrylic are simple but as time goes by you'll find that your collection grows. You'll also begin to regard yoghurt pots and glass jars as valuable pieces of equipment rather than rubbish to be discarded.

SUPPORTS

The term support is used to describe any surface which is used to carry or 'support' a painting. Canvas, paper and canvas boards are all common supports, but a wall, a wooden chest or a chair could also be used as a support for a painting. The paint is not always applied directly to the support because sometimes the artist wants to modify the support in order to provide a more sympathetic or interesting painting surface. The material which comes between the paint film and the support is called the 'ground'.

Getting started

If this is your first foray into painting you will have to start from scratch, but if you are familiar with watercolour or oil painting you should already have some supports which you can use. If you are a beginner it's important to get started as quickly as possible, before you have time to think about how difficult it's going to be. So go to a good art shop and buy yourself a pad of paper or a few canvas boards. Once you're hooked on painting with acrylics – and I'm sure you will be – you can spend more time investigating supports, and learning how to make your own.

Paper

The cheapest and simplest support for painting is paper. You'll find that it can be bought in a range of weights, sizes and surfaces, as spiral-bound, glued pads or as single sheets. Start with a pad of good-quality watercolour paper with a pleasing surface texture.

Watercolour paper is available in three surface types, depending on how it was finished at the mill. 'Hot-pressed' or 'HP' paper has been rolled between hot metal rollers to give it a smooth surface, sometimes with a slight sheen. It is ideal for finely detailed work, such as pen and ink drawings and technical illustrations. 'Cold-pressed' or 'Not' paper (so-called because it is 'not' hot pressed) is passed through cold metal rollers and has a smooth surface with a slight texture. The most highly textured papers are called 'Rough' and have a very obvious

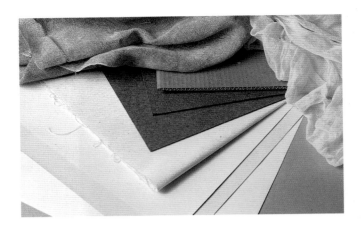

△ *You can buy acrylic supports ready-made or prepare them yourself. Here we show some materials you can use, from top to bottom: scrim, muslin, cardboard, hardboard (rough side), hardboard (smooth side), canvas and various papers.*

surface texture. Start with either a 'Not' paper or, if you work fairly boldly and like texture, a 'Rough' paper.

Papers vary in weight, which is expressed as pounds per ream (480 sheets) or grammes per square metre (gsm). The lightest papers are about 90 lb (185 gsm) and the heaviest are 300 lb (640 gsm), which is as heavy as light board. Generally, the heavier the paper the more expensive it will be.

Why do the weight and surface matter? Well, the surface matters because it affects the way the paper takes the paint, and you'll find that you respond to the way the surface feels as your brush travels across it. The texture of the paper has a very definite impact on the final appearance of the painting, which is why artists are prepared to spend considerable sums on a single sheet of good-quality paper.

Paper should be stretched before use, especially if you intend to use lots of wet, washy paint. Unstretched paper is inclined to cockle, though the heavier the paper the less likely it is to do so.

Stretching paper is easy. You will need clean water, a sponge, a board and gummed paper. Damp the paper with a sponge loaded with clean water. Place the paper right side up on a board, cut strips of gummed paper and gum the paper on the board along the four edges of the paper. Smooth the paper, but don't stretch it; it will flatten naturally as it dries. When the painting is complete and dry, cut the paper from the board, using a craft knife.

Canvas

Stretched canvas is probably the most sympathetic of all surfaces to paint on. The taut cloth responds to the pressure of the brush and the weave of the material contributes to the final texture of the paint surface. Canvases can be bought ready-stretched but the cheapest and easiest way to buy it is on the roll and then stretch it as you need it.

Canvases are made from a huge variety of materials, including linen, cotton, flax, hemp and mixtures that vary in weight, weave and quality, not to mention price. Fine linen is probably the best, being incredibly strong and hard-wearing. Cotton is much cheaper. Look for cotton duck, a tough, densely woven fabric with an even weave.

Other supports

All sorts of materials can be used for acrylic painting. Cardboard is light and cheap. Hardboard is dimensionally stable, offers a choice of two surfaces and can be used for large works with big supports battened on the back to make them firm.

The texture of the support makes an important contribution to the finished painting.

△ *Scrim applied to hardboard with acrylic emulsion.*

△ *Muslin applied to hardboard with acrylic emulsion.*

▽ *Scrim glued to hardboard with acrylic primer.*

▽ *Cardboard prepared with an acrylic primer.*

13

TECHNIQUES

STRETCHING CANVAS

If you have worked with oil you will already know how to stretch canvas, but for those of you who haven't, here goes.

The first thing that should be said is that preparing canvas is not a chore, especially if you are practical. It is an immensely soothing and satisfying process to assemble all the necessary bits and pieces and make something well, especially something you will use yourself.

Why bother?

Why not buy ready-made canvases? Well, cost is one consideration – it is obviously cheaper to buy canvas off the roll. But a more important consideration is the control and choice preparing your own support gives you. The range of canvases available ready-made is limited, and in no way reflects the enormous choice of fabrics available. If you stretch your own, you can select the canvas, the size, the shape and the ground. If you keep a stock of stretchers, canvases and primers, you can make a canvas to suit your own needs as and when you want to.

What you'll need

You will need canvas, which can be either primed or unprimed, and four stretcher pieces to make up into the size that you want. Wooden stretchers are sold in most art shops, in different lengths, so that you can make supports of any size and shape. You will also need tacks and a hammer, or a staple gun, plus wooden wedges – you'll be given a handful of these when you buy the stretchers. Finally, you'll need a reasonable space to work in, especially if you are making large canvases.

▷**2** *Slot the stretcher pieces together, making sure that they are rammed home and square. Some stretchers are cut with two bevelled outside edges, some with only one. Make sure the bevelled edge is down, so that the stretcher doesn't dent the canvas. Cut the canvas, allowing a 2-inch (5-cm) overlap.*

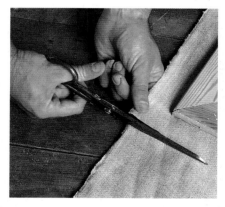

▽**1** *You will need four stretcher pieces, two of each length, scissors or a craft knife, a hammer and tacks or a staple gun, eight wooden wedges and canvas. Here I have used flax, a relatively coarse and cheap material.*

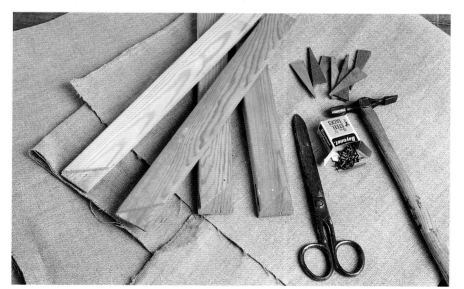

▷**3** *Fix the canvas to the stretcher by tapping a tack into the centre of one side of the canvas. Now tack the centre of the opposite side, followed by the other two sides. Make sure the canvas is taut, but don't pull it or you will stretch the canvas out of true, and could deform the stretcher. Insert tacks on either side of the central tack, working from the centre towards the corners, on the first side, the opposite one, and then the last two sides.*

The process

Fix the stretchers together, lay them on the canvas, making sure that they are parallel to the weave. If you cut the canvas on the cross it will stretch unevenly and become floppy. Cut the canvas using a craft knife and a metal cutting-edge (or scissors if you have a good eye). Allow a 2-inch (5-cm) overlap on all four sides. The canvas can then be fixed to the stretcher, working on opposite sides to make sure the fabric is stretched evenly and kept square. You can use hammer and tacks, but many people find a staple gun more convenient. Don't over-stretch the canvas – if you pull it too tight, you will warp the stretcher. If you are making a large canvas, you may need canvas pliers to give you enough purchase to pull it taut. These are heavy pliers with a broad gripping-surface and can be found in most art shops. If at any time the canvas becomes floppy, you can take up the slack by tapping wedges into the corners.

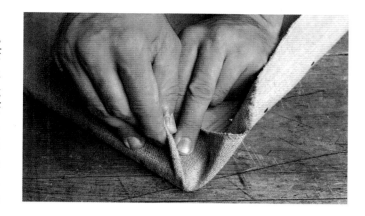

△4 *Make a neat, flat corner by folding the fabric as shown above.*

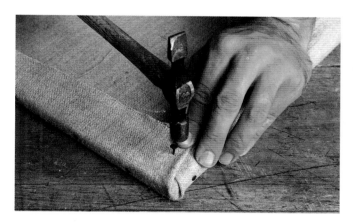

△5 *Fix the corner with a single tack.*

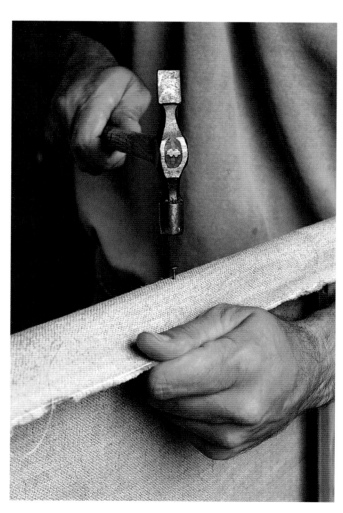

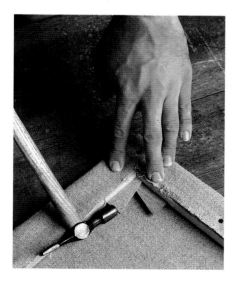

△6 *If the canvas is slack, it can be tautened by tapping wedges into the corners. Gently tap two wedges into each corner, working on opposite corners.*

PREPARING SUPPORTS

Creating a painting involves a combination of inspirational, intellectual and practical processes. For some artists one aspect is more important than another, and the relative importance of each may vary from time to time, and even from painting to painting. The materials you use undoubtedly have a great influence on the way you work. While a good artist should, in theory, be able to create good work with poor materials, it is none the less true that a sheet of wonderful handmade paper or a large linen canvas with a well-applied ground is a marvellous inspiration, and can give you the kick-start you need.

A word of advice – if you are an absolute beginner, it is a good idea to start with a support which is slightly larger than you would normally choose. It is tempting to work on a small scale, and fiddle, but you'll make faster progress if you start with a bold, direct approach, with a big brush on a big support. Once you feel happy with the medium, you can find your own style and scale.

The fabric

The materials used for canvases have different weaves and textures. Linen, which is often hand-made, has a fine, closely woven but slightly irregular texture. It is a mid-grey-brown in colour. It is tough and doesn't stretch, which makes it especially suitable for large canvases, and is interesting and easy to work on. Cotton tends to be softer and bulkier, with a regular, manufactured texture. It is creamy oatmeal in colour. It is not as strong as linen, and is inclined to stretch, especially at larger sizes. If you are using cotton for a large canvas, you should buy the heaviest weight as this is more dimensionally stable. Flax and hessian are cheaper and both have a coarse, open weave and a distinctive warm grey colour. Almost any fabric can be used for acrylic, either stretched or glued to board. Experiment with different fabrics, including embroidery linen, calico and other domestic fabrics. Have a look in specialist theatrical suppliers; they stock all sorts of materials used for painting scenery.

The ground

The 'ground' is the surface on which the paint is applied. It may simply be the support – canvas or hardboard, for example. The 'primer' is the substance which is applied to a support to provide a suitable ground for painting. A primer may be used for several reasons – to increase the adhesion between paint and support, to provide a pleasing colour to work against or to isolate the paint layer from the support. Acrylic differs from oil in that it is not essential to protect the support from the medium. Nevertheless, it is generally advisable to have a painting surface which is slightly absorbent, so that it provides a key, but is not so porous that it is difficult to apply the paint.

Canvas can be bought primed or unprimed. As it is easy to prime a canvas, you might as well buy raw canvas and prepare it yourself. Then you can decide exactly what sort of ground you want.

An important point to remember is that a canvas prepared with an oil-based primer is unsuitable for acrylic. An acrylic primer, on the other hand, can be used for oil.

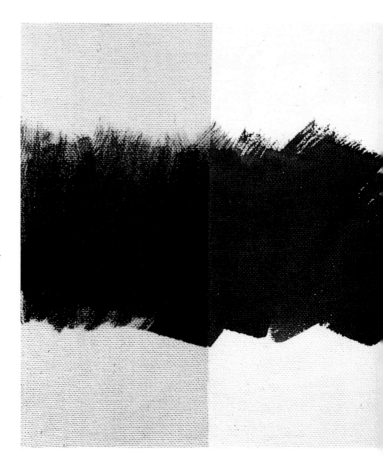

There are really three main ways of preparing a support for acrylic paint. You can use the raw canvas for staining techniques. You can also seal the support – canvas, hardboard or card, for example – without obscuring the colour by covering the surface with one of the acrylic media, or PVA, which is sold in DIY shops as an adhesive and sealer. Because these are transparent, they will not obliterate the colour and will retain most of the texture of the surface. This will be useful if you want to build up surface colour on a linen canvas while retaining the rich mid-tones of the natural fabric in some areas.

You may prefer to start with a crisp, white ground and there are several ways to achieve this. You can cover the support with acrylic primer, either applying it loosely in a single layer to soften the colour of the support or building up several layers to create a brilliant-white surface. Acrylic gesso can be applied in the same way, but has a softer, chalkier, more absorbent surface. Some artists simply paint the support with white paint or mix a tint and apply that. A half-and-half mixture of emulsion paint and acrylic medium or PVA makes an excellent primer.

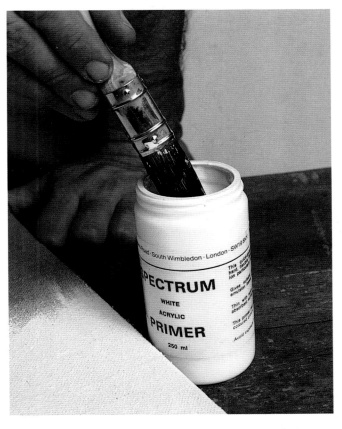

△ *There are several brands of acrylic primer on the market. Any of these can be applied to a support to create a brilliant white ground, which seals the surface and is pleasant to paint on. Here primer is applied to a coarse flax canvas. On such a rough surface it may be necessary to apply several coats of primer.*

◁ *To explore the qualities of grounds a cotton-duck canvas was given four different treatments. From left to right: raw, untreated canvas; acrylic primer; matt acrylic emulsion; acrylic emulsion. Three bands of violet paint were then laid across the canvas. The raw canvas soaked up the paint, hence the dark colour, but the white primer gives the paint a brighter, more transparent quality. Over both acrylic media the paint looks very much the same, and doesn't seem that different from the raw canvas, but the way the paint handled on the canvas was affected. There is no substitute for personal experience, so experiment with different supports and grounds, and you'll find which ones suit you and your intentions.*

TECHNIQUES

CHEAP SUPPORTS

It's all very well working with beautifully prepared and stretched canvases, but it can be expensive and, for the beginner, rather intimidating. There is no short cut to painting. You can read all the books in the world, watch television programmes and videos, go to classes and study the works of Old Masters, but at the end of the day you have to do it, you have to dip your brush in the paint and make a mark on the canvas. And the more you do, the more you learn and the better you get. If you have a few precious canvases, you will be tempted to treat them respectfully. Much better to have lots of cheap supports, so that you can splash paint around, concerning yourself with the process rather than with the end product. You have to run the risk of making mistakes and be prepared to overpaint or discard a canvas. It's difficult to do that if you have spent a great deal of money on the support.

Cheap supports

Have plenty of cheap supports ready to hand. Never find yourself in the position of wanting to paint, of having the time to paint, but being without anything to paint on.

Paper is a splendid, cheap and inexpensive support, but for impasto techniques a more substantial support is needed. Canvas boards are available in a range of finishes – but do make sure you select one

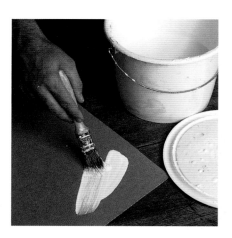

Priming cardboard

△ *Cardboard is fairly absorbent, so if you want to build up transparent glazes or scumbles, or thick impastos, you need to make it impermeable. Here cardboard is being primed with acrylic primer, which creates a brilliant white surface with enough tooth to hold the paint. Acrylic paint would give you a similar effect. Acrylic gesso provides a more absorbent surface. If you want to incorporate the colour of the cardboard in your painting, seal it with one of the acrylic media or PVA.*

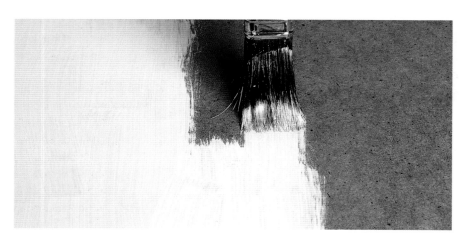

primed for oil *and* acrylic! Though relatively inexpensive, they still involve a certain outlay and some people find the surfaces slippery and unsympathetic. Nevertheless, it is worth experimenting to see if you can find one which suits you.

The best solution, however, is to make your own supports, and once you get into the habit, it becomes second nature and very easy. You need never be caught without something to paint on. You'll also save yourself money and have control over the surface and finish. Here I show you how to make some cheap, simple and pleasant-to-use supports. Do have a go – it's very easy and in time you will find methods of your own that are equally, if not more, satisfactory.

Cardboard

This is a lovely material, light, readily available, inexpensive (or free) and environmentally friendly because you are recycling materials. Card is available in different weights, colours and textures. You can use it in its raw state for watercolour or gouache techniques, but you can also seal the surface with white primer or a transparent medium.

△**3** *The dry gesso surface is then given a key by working over the surface with coarse sandpaper.*

Priming hardboard with acrylic gesso

◁**1** *Hardboard is a tougher, more stable material than cardboard. It can be prepared in much the same way, though. In this case I used an acrylic gesso ground, which has some of the qualities of acrylic gesso. The smooth side of the hardboard is given a bit of tooth by roughening it with coarse sandpaper.*

◁**2** *Acrylic gesso is produced by several manufacturers. Here a first layer is applied using a 1-inch (2.5-cm) paintbrush. The gesso primer is allowed to dry – about ten minutes.*

△**4** *Another coat of gesso is applied, working at right angles to the first coat. This is then allowed to dry. The process may be repeated several times, depending on the type of ground you want. In this way you can achieve a smooth, brilliant-white surface, ideal for detailed work like miniatures and wild-life studies.*

Hardboard

Hardboard is versatile and popular. The smooth side is generally used for painting; it can be given a pleasing surface by priming with acrylic primer, a medium or an acrylic gesso. The rough side has an interesting texture but is extremely absorbent and difficult to work on; it should sized or primed to create a seal and a better working-surface.

Applying muslin to hardboard

The smooth side of hardboard is a bit too smooth for some people's taste, while the rough side is hard to work on and wearing on your brushes. A simple and cheap solution is to give the hardboard a more interesting finish by gluing scrim or muslin to the surface. This is particularly easy with acrylic, because the acrylic polymer resin is really an adhesive. Most of the acrylic media can be used to attach textiles to smooth surfaces.

Muslin is a fine, loosely woven cotton fabric, creamy white in colour. Because it is soft, absorbent and cheap it has plenty of craft and fine-art applications. You will be able to buy it in good craft or art suppliers, in specialist decorating shops or shops

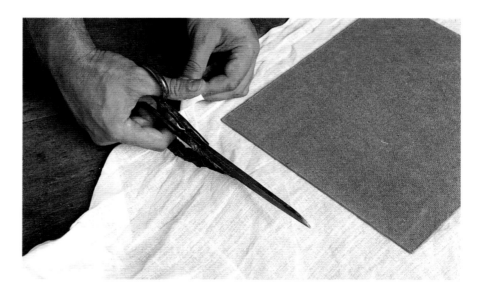

Applying muslin to hardboard

▷**1** *You will need a piece of hardboard, some muslin, scissors, a brush and some acrylic medium or PVA adhesive. Cut the hardboard to the size you want. Lay the board on top of the muslin and cut out a piece of fabric, allowing a 2-inch (5-cm) overlap all round and ensuring that you are cutting parallel to the weave.*

▽**2** *Place the board, smooth side up, on the working surface. Lay the muslin over it. Paste the muslin to the board using the acrylic medium or PVA adhesive. Work from the centre out to the edges, smoothing the fabric as you go, and keeping the weave parallel to the edge of the board.*

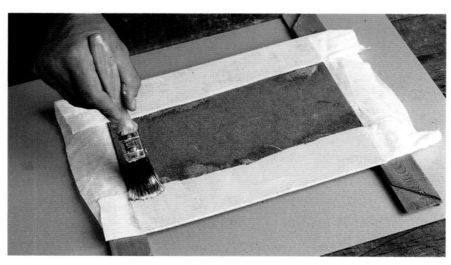

△**3** *Turn the board over, laying it across battens to keep the wet surface clear of the working surface. Fold the fabric over the back of the board as* *neatly as you can and paste it in place. Cover the entire back of the board to prevent warping. Leave to dry.*

dealing in materials for scenery painting. You should also be able to find it in good haberdashery departments. If you have difficulty getting hold of it, try suppliers listed in the small advertisements of the specialist art magazines.

Muslin can be glued to hardboard very easily. If you want to retain the creamy colour and woven texture, use a PVA adhesive or an acrylic medium. Alternatively, you can simply apply it to the board with an acrylic primer. To prevent the board warping, cover the back as well as the front of the board with adhesive or primer.

Applying scrim to hardboard

Scrim is coarse, loosely woven fabric, dark in colour and made from linen, though sometimes it is made from a cotton–linen mix. It can be glued to hardboard to create a surface which resembles a coarse canvas. Like muslin, it is cheap, but you may have to search to find a supplier. It can be applied to the board in the same way as muslin.

In fact, you can apply almost any fabric to board in this way. See what you have around and experiment to see if you like the results. Fluffy fabrics and those with a coarse texture should be avoided.

Applying scrim to hardboard

◁**1** *You will need hardboard, scrim, scissors and acrylic primer. Cut a piece of hardboard to the size required. Lay the board on the scrim and cut it to size, allowing a 3-inch (8-cm) overlap and making sure you cut the fabric square to the weave.*

▷**2** *Lay the board textured side down, put the scrim over it, keeping the weave parallel to the edge of the board. Paste the scrim to the board with acrylic primer, working from the centre outwards, smoothing the fabric as you go.*

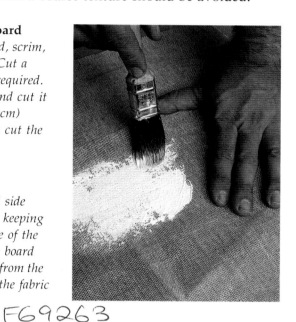

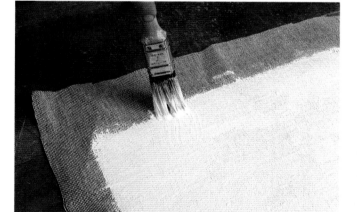

△**3** *Because the scrim is coarse in texture, it will absorb a lot of primer, but the finished surface will resemble a coarse canvas.*

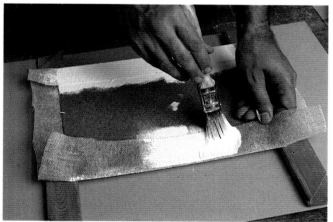

△**4** *Turn the board over and balance it on battens to protect the front surface. Turn the scrim in, making neat folds at the corners. Paste the fabric in place with the primer. Cover the back of the board with primer to prevent warping. Leave to dry – about an hour.*

PAINTS

Paint consists of 'pigment', solid colouring matter, in a 'binding medium', an adhesive substance which holds the pigment in suspension. It is this adhesive or vehicle which allows the pigment to be manipulated on the support. It also creates a bond so that the pigment sticks to the ground.

It is the binding medium in which the pigment is suspended that makes one medium different from another, that gives it its particular character. The binding medium in oil paint is a drying oil – usually linseed oil, but sometimes poppy, safflower or a different type. Watercolour pigments are bound with gum arabic; oil pastels are bound with waxes and oils; soft pastels are loosely bound with gum; egg tempera is bound with egg. With certain exceptions, the pigments used are more or less the same.

What is acrylic?
Acrylic is a polyacrylicate polymer – a modern, manufactured product derived from a synthetic resin. Polymers of many different sorts are all around us; other synthetic polymers in everyday use include plastics, polythene, Perspex, PVA (polyvinyl acetate) adhesives and emulsion paints. Acrylic paint is made by dispersing pigment into an emulsion of acrylic resin and water.

Colour changes
Acrylic paint becomes darker as it dries (in time you will learn to allow for these changes). This is because the acrylic emulsion is slightly cloudy, as you can see if you look at a bottle of medium. But when the water evaporates off as the paint dries, the emulsion in which the pigment is held becomes transparent, allowing the true colour of the pigment to show. You can check this by applying acrylic medium to a surface and allowing it to dry – it will dry to a clear film.

Acrylic paints
These days most paint-manufacturers produce at least one range of acrylic paints. Liquitex acrylic colours were, in the 1950s, the first commercially available acrylic paints. They produce two ranges of

paint, with a total of seventy-three colours. Their tube colour has a buttery consistency which, when dry, retains the mark of the brush or knife. Their jar colour is smoother and more fluid, ideal for watercolour techniques, large areas of flat colour and airbrushing.

Talens's Rembrandt range comprises forty-one tube colours. Their Acrylic Colours, which are sold in 500-ml bottles, are cheaper, more fluid and have a more limited range of twenty-five colours.

Spectrum, a small English firm, produces a range of forty-one colours in their Spectracryl range, available as tube colours and, for larger quantities, in tins. They also produce twenty-one Aqueous Dis-

◁To get the best from acrylic paint you will have to experiment with colours and media. A collection of glass jars with screw tops will be useful. You can also buy plastic pots in a range of sizes. These have press-on lids which are airtight and allow you to keep the mixed colour for a considerable time.

persions, or stainers, which you can use to mix your own paints – a useful and inexpensive way of producing acrylic paint in large quantities.

Winsor & Newton have a range of seventy-five acrylic artists' colours available in 20-ml, 60-ml, 120-ml and 200-ml tubes. There are also thirty-five liquid acrylic colours, ideal for airbrushing, watercolour and pen and wash techniques.

Daler-Rowney's Cryla paints are produced in two consistencies: normal Cryla paints, which have a creamy consistency for impasto work, and Cryla Flow, which is more fluid and therefore suitable for washy techniques and large areas. You can select from forty-nine colours. The System 3 Acrylic range, which is cheaper, is sold in 500-ml plastic pots. Generally, you can mix paints and media produced by different manufacturers quite happily.

What are PVA paints?

Polyvinyl paints are similar to acrylic paints, but the pigment is held in a vinyl emulsion which tends to be less expensive than acrylic. PVA paints have been around longer than acrylic, but they are generally aimed at the school market. They can be mixed with acrylic and acrylic media. Winsor & Newton produce a range of twenty-one vinyl colours. Flashe Vinyl Colours by Lefranc & Bourgeois are available in forty-one colours, plus nine fluorescent ones.

BRUSHES

For artists, brushes are not simply a means of applying paint to the surface; they are also an important means of artistic expression. A well-made brush which retains its shape and has a pleasing spring in its fibres is a pleasure to use and can give you just the lift you need when you are struggling with a particularly difficult passage. A worn-out brush which has lost its shape and won't hold the paint will be difficult to control and very irritating to use. So choose your brushes carefully – and look after them. They are a valuable asset.

Brushes for acrylic

The range of brushes used for painting in acrylic is the same as that used for watercolour and oil painting. What you choose will depend on the sort of work you are going to do, the scale and the techniques. So for wash techniques on paper, select the softer fibres used for traditional watercolour painting, and a short handle because you will generally be working on a small scale and close to the support. For impasto techniques, on the other hand, bristle brushes which can hold the creamy paint are more suitable. A long-handled brush will allow you to stand back from the painting.

Soft brushes

Brushes made from soft fibres are designed to hold dilute paint. They are used to lay down watercolour washes, glazes of thin, transparent colour, and for fine line and detailed work. The best, and most expensive, brushes are made from sable. Sable has both a special springiness and an ability to hold paint and retain a fine point that have always recommended it to watercolourists. Other natural materials used for brush-making include squirrel, ox and goat hair.

Plastics' technology now provides us with an excellent range of synthetic brushes, the quality of which is improving all the time. Many manufacturers combine natural and synthetic fibres to incorporate the colour-holding qualities of the former and the cost-savings of the latter. Some of the best ranges are made from blended fibres.

Because acrylic paint dries so quickly, no matter how careful you are, there is a risk that the paint will dry on the brush, damaging it at best and ruining it at worst. So it is sensible not to put costly sable brushes at risk. Also there seems to be an inherent compatibility between synthetic brushes and synthetic paints.

Stiff brushes

You'll need a stiff brush to handle thick paint in impasto techniques. Because the paint retains the mark of the brush, the shape and size of the brush, its responsiveness to the support and your response to the way it handles are all important parts of the descriptive and expressive process. Traditionally oil-painting brushes were made from hog hair, but once again the chemists have provided us with alternatives which simulate natural materials at less cost.

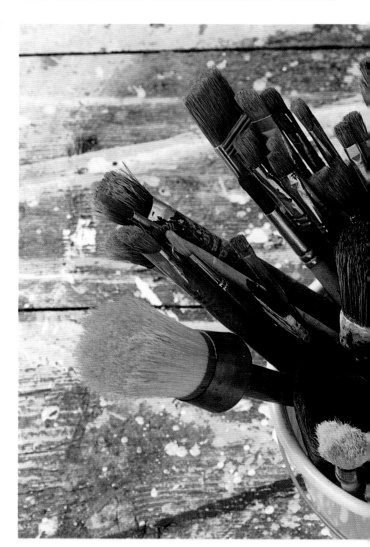

Shape

There are four main shapes of brush: rounds, flats, brights and filberts.

Rounds are used for laying on washes of colour and applying dilute paint to large areas. They are also used for painting fine lines and detail.

Flats are fixed in a flat ferrule and are cut straight at the end. They are used for laying thick colour over large areas. They can be used to create a range of marks and textures. Soft brushes this shape are described as one-stroke brushes, because they were designed for lettering artists and others who needed to make a line of an even width.

Brights resemble flats, but have shorter bristles. The short bristles give more control than the flat, but a less fluid line. Use them for detailed work and short, stabbing marks.

Filberts are also flat, but have curved ends. They

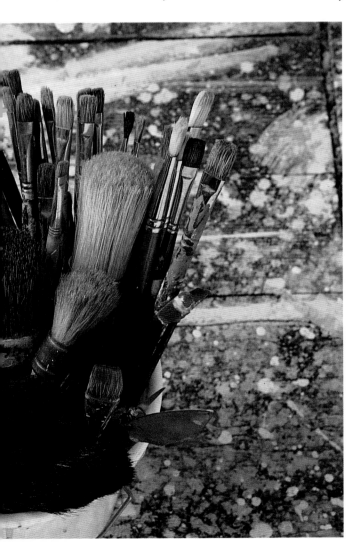

are capable of a great range of gestural marks and tapering strokes.

Other useful brushes include fans, which are used for a variety of delicate, feathery strokes and for blending colours. Then there are mops – large, round brushes used for laying big watercolour washes. Decorators' brushes are very useful for toning the ground or for blocking in an underpainting.

Sizes

Bristle and synthetic stiff brushes are available in sizes from 1 (the smallest) to 12 (the largest). Soft brushes start at 000 and go up to 14 or 16. Ranges of brushes of a particular quality are usually referred to as a series. A number 6 in one series will not be exactly the same size as a number 6 in another. Sizes will also vary between manufacturers, but a number 2 is always small and a number 14 is always large.

Selecting brushes

When you are choosing a soft brush for watercolour, you should test it to see if it retains its shape when wet. A pointed brush should come to a neat point, with no stray hairs sticking out. Good art shops provide a pot of water so that you can do this. Dip the brush in the water and flick vigorously to see that it returns to the correct shape.

Don't spend too much on brushes to start with. Just buy a few and add to your collection gradually. If you are a complete novice, it is a good idea to buy brushes just a bit bigger than you would naturally choose. They will encourage you to be bold in your approach – beginners are inclined to be tentative.

Select a couple of soft, round brushes – about number 6 and number 12 or 14. You'll also need some stiff brushes. Choose bristle or good-quality synthetics – a number 10 round and a number 12 filbert should start you off. Finally, get yourself a decorating brush – a 1-inch (2.5-cm) size will be useful.

*◁In time you will build up a collection of brushes of all shapes and sizes. Look after them – they are valuable assets and if properly cared for will last you for years. **Always** store your brushes bristle-end up.*

GET TO KNOW YOUR BRUSHES

Every brush is capable of a range of marks. Spend time getting to know your brushes – how they feel, the marks they can make, how much paint they can carry and how they respond to different surfaces. Use a scrap of waste paper to see how many marks you can get from each brush. Use both the tip and the side of the brush, and the flat surface of a broad brush. Experiment with long, fluid lines, rapid side-to-side movements and short, stabbing marks with the tip of the brush. You can even use the handle of the brush to scratch back into wet paint – a technique called sgrafitto.

△*Bristle fan, number 4.*

△ *Hog flat, number 6.*

△*Polyester watercolour brush.*

△*Mixed-fibre round.*

△*Synthetic ¼-inch (0.5-cm).*

△*Decorators' brush, 1 inch (2.5 cm)*

△*Round bristle.*

CARE OF BRUSHES

Brushes should be looked after – they are a vital part of your kit and are expensive to replace. The rapid drying-times of acrylic paints and media can be hazardous to brushes, and to palettes. Once paint has dried on to your brush, it is very difficult to remove.

Develop the following good practices from the beginning. Never let paint or media dry on the brush. Wash your brushes in water as you go. If you don't have time, or don't want to interrupt the flow of the work, immerse the brushes in water if there is a chance that you may not use them again within the next ten minutes.

Wash brushes thoroughly with water and soap after every painting session, making sure that you remove all the paint from around the ferrule.

If paint does dry on the brush, it can be removed only with a solvent. Methylated spirits will soften and remove the paint, but it is a drastic measure and the brush will never be quite the same again. The best advice is to avoid this situation.

Cleaning brushes

◁**1** *Wipe the brush on a rag to remove surplus paint. Swirl the brush vigorously in a pot of water to remove as much paint as possible. Wipe it again on a rag. Put some washing-up liquid in the palm of your hand and work the brush around in it or work it over the surface of a bar of plain soap.*

▽**2** *Work up a lather, making sure you get the soap right up into the fibres and around the ferrule. If paint dries around the ferrule, it will become loose and the brush will start to shed hairs. Dried paint can cause the fibres to break at this point.*

△**3** *Rinse the brush under clean running water, making sure you wash out all the soap. Shake the brush briskly to remove surplus water, then shape it gently with your fingers. Sable and soft-fibre brushes should be returned to shape with a swift flick of the wrist. If any hairs do stick out, smooth them into shape. Leave brushes to dry brush-end up in a jar.*

ACRYLIC MEDIA

Used straight from the tube or thinned with water, most acrylic and PVA paints will dry to an opaque, rather matt finish. But extensive ranges of media are available which allow you to change the character of the paint, the way it performs and the way it looks. These are an enormously exciting discovery for people unfamiliar with acrylic paint.

Every manufacturer produces a different range of media, with different names and slightly different qualities. This is because acrylic is such a new medium that names and products have not been standarized – in fact, manufacturers are still developing new products. Oil and watercolour, on the other hand, have been around for hundreds of years in the form we know them, and most manufacturers produce broadly similar ranges of products.

I've grouped media according to what they do, and have talked generally, mentioning specific products with which I am familiar. You may have to shop around to find some of these, as your local artists' supplier may stock only the products of one or two manufacturers. Start by experimenting with whatever is readily available. As you become more familiar with acrylic, you will undoubtedly want to achieve particular effects or to modify certain characteristics. You can track down specialist products by studying advertisements in practical art magazines. There are many mail-order suppliers who hold a much wider range of art materials than the average local art shop – and their prices are often more affordable.

Retarder

One of the outstanding characteristics of acrylic is the speed with which it dries. Some people find this a problem, especially if they are used to working with oils, which dry slowly, allowing you to continue to work into the paint surface over a number of days. Acrylic retarder slows the rate at which acrylic dries.

However, rather than 'retarding' the drying-time of acrylic and trying to ape oil-painting techniques, you should try to exploit and enjoy the inherent qualities of the medium. Work broadly and quickly, building up layers of paint in scumbles and glazes, each layer modifying the previous one. Or try a slower, more meticulous technique, laying down areas of hatched colour using tiny brushstrokes.

Use retarder for special situations in which you need time to achieve a delicately blended effect. In the final stages of a portrait, for example, you may want to work slowly to create smoothly modelled flesh tones.

Retarder may slightly increase the transparency of the paint.

Flow-improver

This additive is useful if you want to create an area of flat, even colour and eliminate brushmarks. It is also called water-tension breaker, because that is how it improves the flow of the paint. You can achieve the same effect by adding a little washing-up liquid to the paint – if you sniff a bottle of one of these flow-improvers, you'll notice that the smell is very like that of household detergent, and if you use too much it is inclined to foam.

Mix one or two parts flow-improver with twenty parts water or acrylic medium before adding it to paint. It is especially useful for staining canvas and can also be used when paint is to be applied with an airbrush. Don't scrub the paint on to the canvas, as that may lead to frothing, and the dried bubbles will create small pinpricks which allow the white of the canvas to show through. Get rid of these by going over the surface, popping the bubbles with a pin, or use an anti-foaming agent. This is an oily liquid which should be added carefully, a few drops at a time – over-application will cause the paint surface to open up and become streaky, a phenomenon called cissing.

Gloss, matt and glaze media

These are acrylic emulsions which can be added to acrylic paint to extend it, make it flow and increase its transparency. Like all acrylic emulsions, they can be diluted with water, and although milky when wet, they dry to a clear, transparent film. Gloss medium added neat to paint will dry with a slightly shiny surface, though the more water you add the less glossy the surface will be. Matt medium should be used when you want to extend or thin the paint without its drying to a sheen. Both gloss and matt media can be used for glazing techniques, though

△*Cadmium red paint straight from the tube.*

△*Cadmium red plus texture paste.*

△*Cadmium red plus matting agent.*

△*Cadmium red plus glazing medium.*

▽*In this picture we show the media we had in the studio – just a selection of what is on the market.*

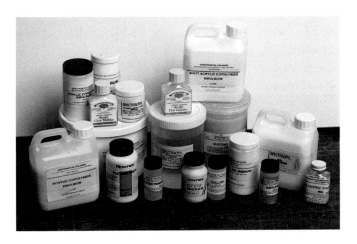

some manufacturers also produce a special glazing medium. The media produced by different manufacturers will have slightly different qualities and drying-times, so you should experiment and get to know them.

Gel medium

Gel media are usually available in a paste-like form. They are designed to increase the impasto qualities of acrylic paint without increasing its opacity. The appearance of the medium and its qualities vary from manufacturer to manufacturer, so don't assume that because gels have the same name they work in the same way.

Texture paste

Like the gel media, texture pastes are designed to increase the impasto qualities of acrylic paint, but there is a filler in the acrylic emulsion which makes the medium opaque. Some pastes are very thick and if they are to be used on a flexible surface like canvas, it may be necessary to add another medium to prevent cracking. They are sometimes described as 'modelling pastes'.

29

TECHNIQUES

MAKING A 'STAY-WET' PALETTE FOR ACRYLICS

Acrylic paint is almost impossible to remove from wooden palettes, so use glass, Perspex or a sheet of melamine – or any smooth surface from which the dried paint can be scraped fairly easily. Paper palettes are useful because they can be thrown away at the end of the painting session, or you can make your own disposable palette by covering a wooden palette with tinfoil.

Acrylic dries quickly on brushes and palettes as well as on the support. Aways have several jars of water around to keep brushes wet. A household water-sprayer, the sort used for spraying plants, can be used to keep the paint surface moist, thus slowing the rate at which it dries. The palette should also

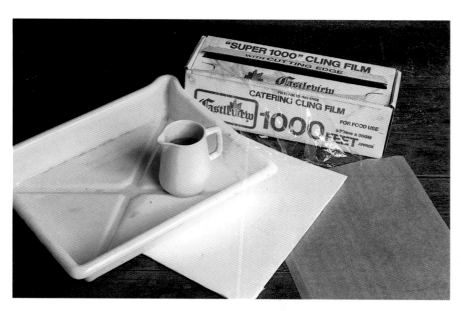

◁ **1** *You will need a shallow plastic tray, blotting paper, waxed greaseproof paper and clingfilm.*

▽ **2** *Cut the blotting paper to fit and lay it in the base of the tray. If the blotting paper is thick, one sheet will do; if it is thin, you should cut several pieces and lay them on top of each other. Pour water on to the blotting paper, making sure it is thoroughly soaked.*

◁ **3** *Cut a piece of greaseproof paper to size and lay it over the wet blotting paper.*

be sprayed at intervals to prevent the paints from drying out. If you intend to leave the painting for a few hours, cover the palette with clingfilm to keep the paints workable. With oils you can leave paint on the palette and, depending on the conditions, they will be usable several days, or even weeks, later. This is not the case with acrylic, and unless you are very organized, you will waste paint at the end of each painting session.

Special 'stay-wet' palettes are designed to keep paints moist. Daler-Rowney produce one which consists of a plastic tray the base of which is lined with a sheet of absorbent paper. This is soaked with water and a sheet of tough, water-permeable paper is laid over it. Moisture comes through, providing a mixing surface which stays damp and prevents the paint from drying out. Acrylic paint treated in this way can be kept workable for weeks.

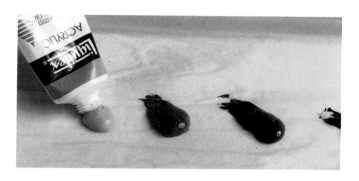

△**4** *Squeeze blobs of paint on to the greaseproof paper.*

◁**5** *If the palette becomes too messy, you can simply replace the greaseproof paper.*

◁**6** *As long as the blotting paper is kept moist, the paints will not dry out. At the end of a painting session cover the whole tray with a sheet of clingfilm.*

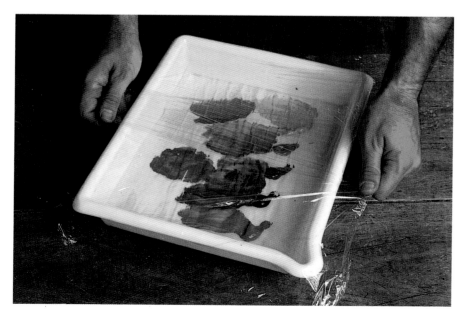

31

Colour

WE ALL have a natural creative talent but not all of us have had the opportunity to exploit it. Nevertheless, it is there, even in those of you who picked up this book thinking, 'I can't draw a straight line, let alone paint.'

After all, you could paint once – all children paint and draw with great confidence and inventiveness. Unfortunately, we lose that confidence as we grow older and forget what we once knew instinctively.

This is particularly evident in the field of colour. Children enjoy colour, handling it with great freedom, often applying it in an apparently random fashion. They paint what they feel as well as what they see. But as they get older they become more concerned with 'accurate' depictions of reality, censoring their natural responses.

One of the purposes of this book is to help you unlock your artistic talent by overcoming your inhibitions and tapping in to that creative freedom you had as a child.

The best way to learn about colour is to become aware of it in the world about you, to look at the work of other artists, especially the great colourists like Matisse (1869–1954) and Titian (c. 1487–1576), and above all to play with paint, getting to know pigments, the way colours respond to each other and what happens when they are mixed together.

The colour wheel is a useful device that helps you understand colour relationships. Primary colours – red, yellow and blue – are mixed to produce the secondaries: red and yellow give orange; red and blue, violet; and yellow and blue, green. Colours opposite each other on the colour wheel are called complementary pairs. They have a special relationship with each other; green and red are complementary pairs, as are yellow and violet.

THE LANGUAGE OF COLOUR

I'll start with some definitions, because without an appropriate vocabulary it is difficult to talk about colour. Every colour has four qualities: its hue; its tone or value; its intensity or degree of saturation; and its temperature.

Hue

This is the colour of a colour – its name. Blue, red and green are all hues, as are blue-green and yellow-green. The term 'hue' does not encompass the 'tone' of a colour, so red is a hue, while light red or dark red describes a tone of a particular hue.

Tone

This is a light or dark variation of a hue – also known as a value, or tonal value. Every colour in nature has a tonal value which can be assessed by comparing that colour against a grey or tonal scale. Tone is not about the amount of white or black mixed into a colour – every pigment on your palette has a tonal value, even in its pure, unmixed state. This is a very important point to remember.

Why is the tonal value of a colour important? Well, colours of the same value have a harmonious relationship; they sit together comfortably on the picture plane and don't vibrate. Contrasts of tone, on the other hand, can be used to create energy in a painting and to imply three dimensions. If you are painting a landscape, for example, you could create a sense of depth by using colours which are close in

tone on the horizon, using tonal contrasts and crisp edges in the foreground to persuade the eye that these are nearer to the surface plane of the picture.

Tone can be a difficult concept to grasp, but if you look at a black and white photograph which translates colour into tonal values you begin to understand what I mean. If you look at a subject through half-closed eyes, you will simplify the tones, making it easier to see the broad tonal arrangements. Or you can look at the subject in a dark, reflective surface – a sheet of black Perspex or a piece of glass painted black on one side will be very helpful.

Saturation

The brightness of a colour, also described as intensity. The opposite of an intense or saturated colour is a muted or subdued colour, a colour which has been 'knocked back' or dirtied. A bright primary yellow is an intensely saturated yellow, while yellow ochre is a less saturated, more muted colour. Bright cadmium yellow and cadmium red are both highly saturated colours, but if you peer at them you will see that the yellow is very light in tone, whereas the red is much darker.

Colour temperature

Colour has an impact on many aspects of our life. It can affect our mood, the way we perceive objects and spaces, and it even has physiological effects – raising or lowering our pulse rate, for example.

One of the better-known though not necessarily well-understood phenomena is colour temperature. It has been found that some colours look warm and others look cool, and that there is a general consensus about which are which. Reds, oranges and yellows tend to be perceived and experienced as warm colours, while blues and greens are cool. In an experiment people in a red room estimated the room

▷ **A basic palette**
*Start with a limited palette of colours. I have suggested the
following thirteen, from which you should be
able to mix all the colours you will need. From
left to right: titanium white, ivory black,
cobolt blue, cerulean blue, idanthrene blue,
Hooker's green, cadmium yellow pale, yellow ochre,
raw sienna, raw umber, burnt umber, cadmium red,
permanent alizarin crimson. You can limit yourself further
by starting with black, white, one blue, one yellow, one red
and raw umber.*

temperature several degrees higher than people in a blue room at exactly the same temperature.

Colour temperature is complicated by the fact that some cool colours are cooler than others, so a blue-green is cooler than a yellow-green. Similarly, some warm colours are hotter than others, so a scarlet with a lot of yellow in its make-up will be seen as warmer than a crimson which has a bluish bias.

So what are the implications for the artist? A knowledge of the way that warm and cool colours behave allows you to exploit them to create mood in a painting. Warm colours, for example, are lively and energetic; they sparkle and dominate the picture surface. Cool colours, on the other hand, are more subdued and soothing. Warm colours are said to advance, whereas cool colours recede. If blobs of blue and red of equal size are placed side by side on a canvas, the red colour will appear to occupy a plane in front of the blue – the red blob will also look larger than the blue. These qualities can be manipulated to create an illusion of three-dimensional space within a painting – by using primarily cool colours on the horizon, with warm colours in the foreground, you can suggest recession and depth in a picture.

Primary, secondary and tertiary colours

The primary colours are red, yellow and blue, and are so called because they cannot be mixed from other colours and, in theory, every other colour can be mixed from them. Secondary colours are mixed from the primaries: blue and yellow gives green; red and yellow, orange; red and blue, violet. The tertiary colours are created by mixing a primary with a secondary. There are six tertiaries. Going round the colour wheel on the previous page you would get: blue-green; yellow-green; yellow-orange; red-orange; red-violet; blue-violet.

Complementary colours

The colours opposite each other on the colour wheel are called complementaries, or complementary pairs. So red and green, orange and blue, and yellow and violet are all complementary pairs. Complementary colours have a special relationship with one another. They enhance each other when placed side by side – so green looks brighter when placed alongside red. Remembering that a little of a warm colour like red goes a long way, you could do what many of the Impressionists did and introduce touches of red into an area of green grass to give it a lively sparkle. On the other hand, if a colour looks too shrill, you can subdue or mute it by adding a little of its complementary. Mixing complementary pairs in varying proportions allows you to create a whole range of subtle, beautiful and useful muted colours.

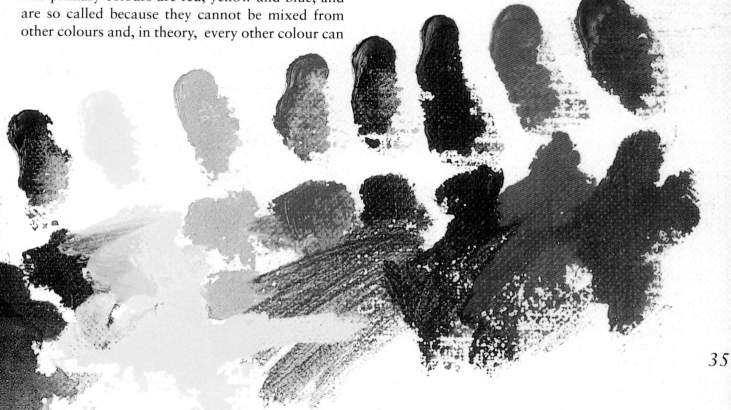

Getting started

*I*N THIS chapter I describe and illustrate some basic paint-ing techniques. Master these and you will be able to start a painting. The best, indeed the only, way to get to know a medium is to use it. So gather together a few brushes and paints and as much paper, hardboard and cardboard as you can lay your hands on and have a go.

Don't bother about trying to create an image; just concen-trate on getting to know the materials and medium. Explore colour mixtures, the way paint handles on different sur-faces, and the way that it is affected by adding media. Notice how long the paint takes to dry in different thick-nesses and on different surfaces.

To preserve the brilliance and clarity of your colours, avoid over-mixing them and limit colour mixtures to two or three tube colours plus white. Plan colour mixtures. Don't stab your brush into one colour after another and then scrub them together in a random way. Have lots of clean water to hand and rinse your brushes at regular intervals.

If you are already a painter, many of the techniques will be familiar, but you'll find that acrylic has qualities which are unique to it. Try and enjoy the medium for what it is, rather than concentrating on the extent to which it can emulate the techniques of oil or watercolour.

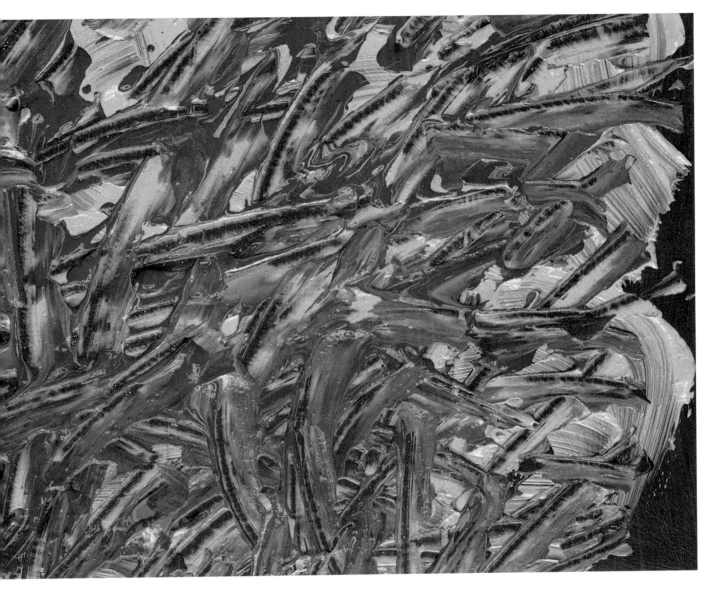

△Acrylic can be used to create rich textural surfaces. Yellow paint mixed with a thickening agent was laid over a flat red base colour. Red paint extended with an acrylic medium was trickled on and the artist then scratched back into the surface with the handle of the brush – a technique called sgraffito.

◁Cerulean blue mixed with medium is dripped on. The blue looks particularly intense because orange is its complementary. Even a thick paint surface like this will dry completely within hours.

37

TECHNIQUES

MIXING PAINT

The role of colour in painting is enormously important. It can be used 'descriptively' to depict the colour of a subject in order to communicate an image to a viewer. This is the simplest use of colour – grass is green, the sky is blue and the sun is a golden orb. The colour of the surface of an object is called the 'local' colour. This is the colour unmodified by reflections and shadows. An obvious example of local colour is a red pillar box which is red because it has been painted red. If you wanted to

create a recognizable 'symbol' for a pillar box, you would match the red paint. But when you look at a pillar box, you don't see a simple red. So it would be rendered in many different colours in a painting to capture the light and dark tones and the colours reflected from surrounding objects. The result will be more convincing than an image painted solely in the local colour.

Colour can also be used 'expressively' to describe an emotional response to a subject or to induce an emotional response in the viewer. This is much more interesting and allows the artist considerable scope for creative interpretation – and fun. Each of us has a unique colour sense. It can be expressed in the clothes we wear, the way we decorate our homes and the objects we choose to have around us. This very personal view of the world must of necessity

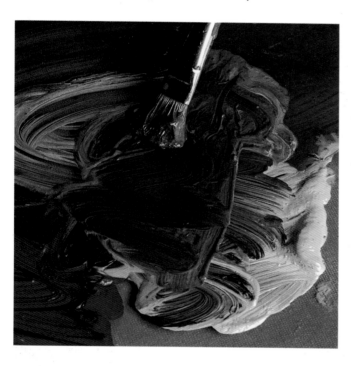

△ Using a palette
Use a large palette to give you plenty of room to mix colours. Squeeze dabs of colours around the edge of the palette and use the centre for mixing.

▷ Mixing colour
The top patch of green was mixed on the palette from cobalt blue and cadmium yellow. The bottom patch of colour was created by dipping the brush into yellow paint then into blue, and applying it to the support so that it is incompletely mixed. This is an example of broken colour.

became a part of our art. The Fauves (the name means 'wild beasts') were a group of artists, including Matisse and Derain (1880–1954), who for a brief two-year period sought to use bright, pure colour in an apparently arbitrary way to create emotional and decorative effects.

Colour can also be used 'constructively' to describe forms and create the illusion of three dimensions on a two-dimensional surface. This is where the advancing and receding qualities of warm and cool colours come in: they can be orchestrated to give objects a sense of volume. A round red ball would be painted with a bright, hot red on the surface nearest the viewer, while the surfaces moving into the background and turning away from the viewer would be depicted with cooler shades of red, making that area appear to recede.

The range of colours available straight from the tube is far too limited to perform all these three functions, so it is necessary to mix colours. The range then becomes almost infinite.

New colours can be created in several ways. You can mix them on the palette, then apply them to the support. You can work another colour into a colour that is already on the support. Colours do not always have to be thoroughly mixed – in fact, some of the most exciting effects are achieved by the use of 'broken' or partially mixed colours. Passages of broken colour are exciting because the colour-mixing is completed in the eye and mind of the viewer, creating tensions and ambiguities. The closer you are to an area of broken colour, the more clearly the dabs of colour can be seen, but as you move away they dissolve and are read as a single new colour.

▽ Pointillism
This is a technique devised by the artist Seurat (1859–91). Regular, geometric dots of unmixed colour were applied to the canvas in carefully worked-out combinations. The technique, also known as Divisionism, is an example of broken colour and optical colour-mixing, but applied rigorously as originally intended it lacks spontaneity.

△ Mixing on the canvas
Here yellow paint is worked into a patch of green on the canvas. Colours are changed by the colours alongside them, so it is likely that when you see a colour in situ *you will want to change it. One of the secrets of good painting is being prepared to change your mind without over-working the paint surface.*

WET IN WET, WET ON DRY

One of the most direct methods of working is to apply paint to the support and continue working into the wet paint surface. But there are several techniques that allow the paint surface to dry before layers of transparent, opaque or broken colour are applied on top. Each method has an entirely different appearance and it is worth spending some time exploring these different approaches.

Wet in wet

The advantage of working wet in wet is that colours can be modified on the canvas, where subtle transitions from one area of colour to another can be achieved without hard edges. Acrylic used straight from the tube or diluted with water begins to dry very soon, so you will need to work quickly if you want to achieve blended paint effects. Thinly diluted with water, acrylic paint can be used to create effects which resemble watercolour; used direct from the tube, or only slightly thinned, it resembles oil paint.

Wet in wet
△1 *Lay a patch of creamy colour and, while it is still wet, work another colour into it. Use a Flow Formula paint, or add a retarding medium to slow the drying-time. Working wet in wet, it is possible to mix colour on the canvas surface and to achieve blended effects. Compare this with the crisp edges achieved working wet on dry.*

Wet on dry
△1 *Lay a patch of colour and allow it to dry. Now paint a band of fluid colour over it and leave it to dry.*

◁2 *The band of paint dries with crisp, clearly defined edges.*

If you want to keep the paint workable for longer, spray the support with water as you work, or add a little retarder, which slows the drying-time. Experiment with different types of paint. You'll find that Daler-Rowney's Flow Formula tube paint is slower to dry than more paste-like paints and suits a wet-in-wet technique. Liquitex's Jar Colour is even more fluid.

Wet on dry

If colour is applied over a dry paint layer, it is possible to create hard edges and crisp details. Once dry, acrylic paint is insoluble in water, so even liquid colour will not lift the underlying paint layer.

You will find that by applying wet paint over dry,

it is possible to work accurately and with a great deal of control. It is also possible to create subtle and complex layers of thin colour.

Red pepper: wet in wet

▽**1** *Find a single, simple object like this pepper and do a quick painting using wet in wet techniques. Don't fuss too much – the process is what's important, rather than the result.*

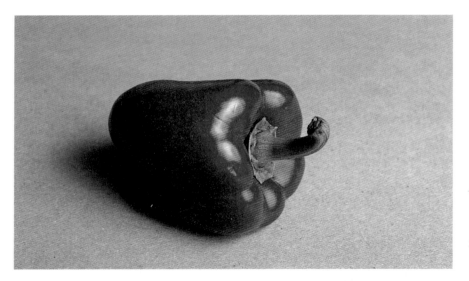

△**2** *Put out a few colours on your palette. Study the subject carefully through half-closed eyes. This will help you to isolate and identify the broad areas of colour. Mix the colours you see and put them where you think they should go.*

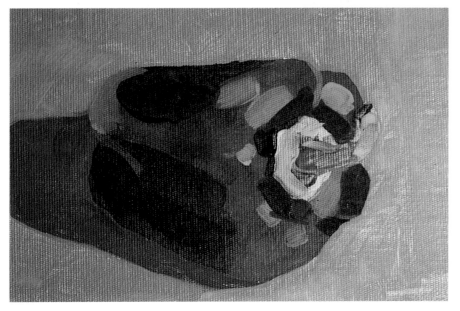

◁**3** *Notice the way the colour feels as you apply it, the rate at which it dries and the way it dries. Here the varied red tones were laid on wet in wet and merged into one another. The background was put down once the pepper had dried, allowing the artist to redefine the outline of the pepper.*

TECHNIQUES

BLENDING

The quality of the edges between one colour and another, and one tone and another, is important in painting. We have already looked at the way in which you can achieve clean, crisp edges by painting wet on dry. Often, however, you will want to achieve soft, blurred edges.

All blending in acrylic is achieved by working wet in wet. As long as the paint is still wet, you can soften the borders quite simply by blending the colours using a soft brush. You can also use a feath-

ering technique. For creamy paint use a bristle brush, for watery paint use a soft-fibre brush – fan-shaped brushes are ideal. Hold the brush loosely in one hand and, using a brisk side-to-side motion, work it across the paint surface.

If you are using acrylic paint on paper, in a water-colour technique, you can achieve softly blurred edges by flooding thinly diluted paint on to wet paper, or into wet paint – the second colour will gradually bleed into the first.

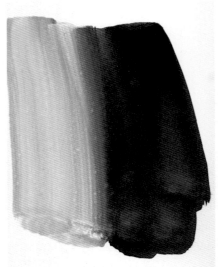

▽**2** *The two colours will bleed into each other, creating a blurred edge. This technique is useful for the softly blended effects required for flesh tones.*

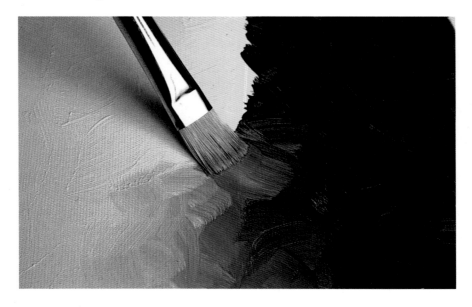

Feathering
△*To practise, lay two patches of creamy colour side by side. Using a stiff bristle brush, blend the colours using a feathering technique.*

Bleeding colour
▷**1** *Lay a patch of liquid paint on a support. Here we have laid paint on a piece of canvas board, but you could also do this on absorbent paper. Mix a dilute solution of a second colour with water and lay a band of this alongside the first colour. Make sure the colours touch, but don't attempt to blend them.*

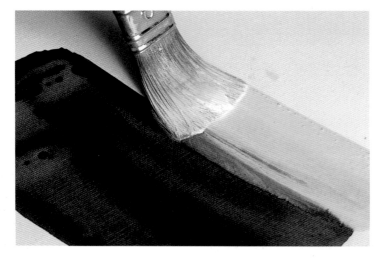

TECHNIQUES

SCUMBLING

On page 39 we briefly discussed the concept of 'broken colour' or 'optical colour-mixing', in which the colour-mixing process is completed in the eye of the viewer. This process is vital for adding textural interest to a painting – creating passages of shimmering, ambiguous colour that dissolve and resolve as you move backwards and forwards in front of the painting. Scumbling is a broken-colour technique in which paint is applied in such a way that the underlying colour, or the colour of the support, shows through. The base colour modifies the overlying colour to create a third colour. A thin layer of opaque or semi-opaque paint can be applied loosely over a ground or over a painted area. The paint can be applied with a stiff brush, a cloth or even the fingers. It can be used to modify an area without obliterating it – to 'knock back' a colour that is too garish or to bring together a passage in which there is too much tonal contrast.

△*Green, dryish paint was applied briskly to a canvas, using a stiff bristle brush. The paint lodged in the recesses of the textured surface. The white of the canvas shows through in the high areas of the weave, creating a paint surface with a brilliant sparkle.*

△*In this example the base colour is again red, but this time it was applied flatly with little texture. Thin, opaque colour was then applied with broad, sweeping gestures which almost obliterate the underlying colour, creating a subtle, partly blended effect.*

43

TECHNIQUES

TRANSPARENT COLOUR

Acrylic can be used thinly on paper; used opaquely it resembles gouache and used transparently it resembles watercolour. But it differs from both of them in that when dry it is insoluble – the paint cannot be dissolved or lifted from the paper surface.

True transparent watercolour is created from a series of transparent washes of colour applied to white paper. The paper should be stretched – see page 12 for instructions. You will need a white plastic or ceramic palette with recesses in which you can mix the washes, or several saucers will do. To mix a wash, put a little blob of paint on the palette, add several brushfuls of water and mix it with the paint. Test the colour and transparency of the paint on a scrap of paper. When working with transparent paint you should work from light to dark, leaving the white of the paper to stand for the lightest areas. To see how this works, lay a wash on a piece of paper and allow it to dry. Now lay a band of the same wash across the first band and leave that to dry. The area where the two washes overlap will be darker than the single wash but still transparent.

Lemon: Transparent washes on paper

▽**1** *Choose a single, simple object and set it against a plain background. Stretch some watercolour paper.*

▷**2** *Mix washes of colour in a palette. Applying the paint in thin washes, dropping in other colours wet in wet. Work quickly to avoid the paint drying with hard edges. When the first wash of colour is laid, leave to dry and then apply a second, overlapping wash.*

▷**3** *Here you can see the way successive layers of transparent washes build up to create a range of tones. You will find that some colours are more transparent than others, and are therefore more suited to this technique. If you are used to traditional watercolours, you will find acrylic dries much faster and is actually very different.*

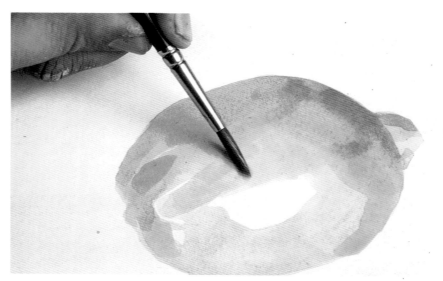

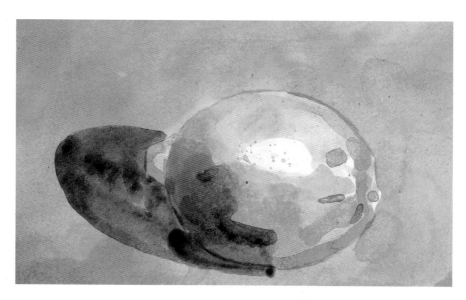

TECHNIQUES

IMPASTO

The term 'impasto' describes paint applied thickly so that it retains the mark of the brush, the knife or whatever implement was used to apply it. In the wash technique the paint sinks into the paper and there is no surface texture; an impasted surface, in contrast, has a low-relief, three-dimensional quality.

The textural qualities of paint are an important part of any painting. Surface texture can be used descriptively. If you are painting a piece of driftwood or the bark of a tree, you could search for paint textures that mimic those of nature.

Texture can also be used expressively. A picture in which the artist has used broad swathes of thick, juicy paint will have a very different impact on the viewer than one in which the artist has used the paint in a more restrained way, with thin layers of scumbles and glazes.

Apple: Impasto with brush

▽**1** *Find a simple subject and use it to explore the textural qualities of acrylic using different brushes and brushmarks.*

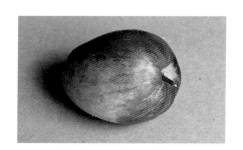

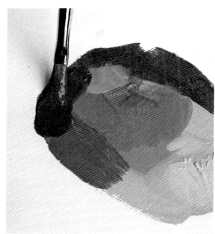

◁**2** *Use creamy paint and a bristle brush. Add texture paste or thickener to the paint to increase the textural qualities and its ability to hold the marks of the brush. Try not to overwork the paint surface, but be aware of the marks made by the brush.*

▽**3** *Here you can see the way the artist has built up thick areas of impasto, and has used the brushmarks to follow and describe the form of the apple.*

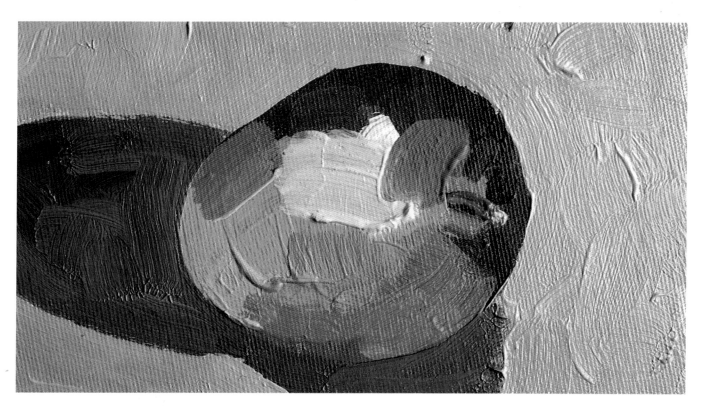

KNIFE PAINTING

Two types of knife – palette and painting – are used for oil and acrylic painting. Palette knives have wooden handles and broad, flat, flexible blades. They are used for mixing paint, cleaning the palette and scraping paint from the support, and rarely for painting. Painting knives have cranked handles and this makes them springy and responsive, and also keeps your hand away from the support. The blades are made from thin steel and are available in a wide range of shapes and sizes, from small, triangular blades ideal for detailed work to longer blades with curved tips for large-scale work. Every manufacturer produces a slightly different range, so shop around until you find a selection that suits you.

Knives can be used to build up a rich, thick impasto, to add texture to parts of a painting or to scratch back into the paint surface. Knife painting encourages a bold approach and allows you to cover

The marks of the knife

A painting knife can be used to lay on broad swathes of thick paint, creating rich impastos with a variety of exciting surface textures. For example, by using the flat of a broad knife and lifting it repeatedly from the sticky paint surface, you can raise lots of little peaks. But the tip of a finely pointed knife can be used to create fine lines and striations. Experiment with creamy paint and a selection of knives. Add texture paste for bolder impastos.

the canvas quickly with fresh paint.

Experiment with different tools, materials and supports from time to time – it stops you getting stuck in a rut and keeps your work fresh. See what happens when you use a different knife or brush.

Knives are ideal for working alla prima, a fast and direct method of painting in which the picture is completed at one sitting and consists of a single layer of opaque paint. This contrasts with traditional techniques in which a painting is developed in stages, starting with an underpainting and building up layers of scumbles, glazes and impastos.

Alla prima pictures are painted wet in wet and each dab of colour is put down more or less as it will

appear in the final painting. It is ideal for landscapes because it allows artists to record their impressions quickly and produce paint surfaces which are fresh, lively and highly textured.

Experiment with knife painting to see if it suits you. Get to know the qualities of the knife by experimenting on scrap paper – see how many different kinds of mark you can get from a single knife.

▽ **2** *Study the subject carefully and isolate the colours and tones. To keep the paint surface fresh, mix the colours on your palette and put dabs of mixed paint on to the support. Try not to mix colours on the support, as the paint surface can easily become dull and overworked.*

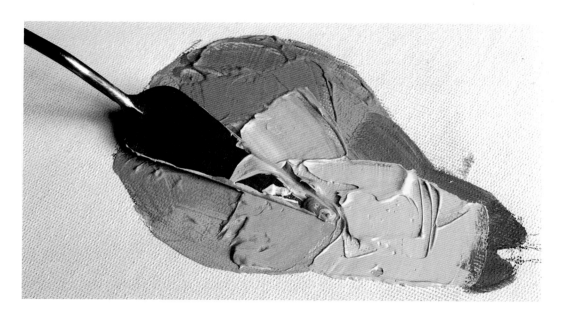

Pear: Knife painting
▽ **1** *To practise knife painting choose a single, simple subject, like a vegetable or a piece of fruit. Set it against a contrasting background.*

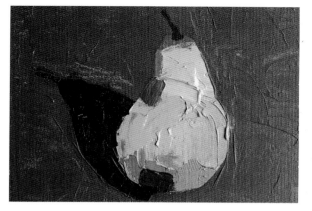

△ **3** *The artist has produced a simple study using fresh, creamy paint applied quickly and boldly. Compare the paint surface with the apple on page 45.*

SGRAFFITO

The term 'sgraffito' comes from the Italian for scratching. It describes a technique in which the artist scratches back into the paint surface to create patterns, outlines or images. Sgraffito designs can be worked into the wet paint surface with any pointed tool, the tip of a painting knife, a pencil or the handle of a brush. Patterns can also be scratched into a dry paint surface with a sharp implement. In the figure painting on page 72 the artist deliberately breaks up the surface of thick watercolour paper to create interesting textures.

Experiment with sgraffito. Paint a layer of thick paint on to a support and scratch back into it with a variety of implements to reveal the white of the support. Study the effect from close to, then view it from a distance. As well as adding texture to the picture, sgraffito is also an example of broken colour: the white of the support and the overlying colour will blend to create different colour and tonal effects. You can also use sgraffito to scratch through one colour to reveal an underlying colour.

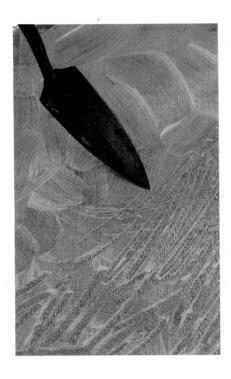

Sgraffito with a knife
You can create a range of interesting effects by scratching back through layers of paint to reveal the underlying colours. Experiment with different colours and different implements on scrap paper.

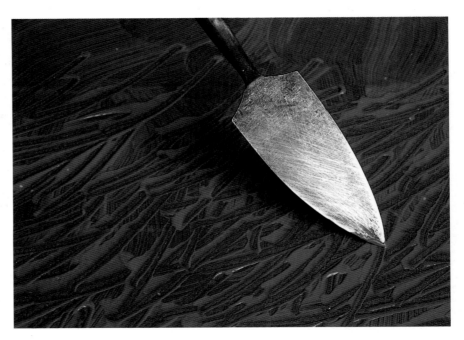

Onion: Sgraffito with a knife

◁**1** *Sgraffito can be used descriptively – to draw in the veins of a leaf, for example, or as here to draw the striations on an onion bulb. Select a suitable object and explore the potential of the technique.*

▽**2** *Start by blocking in the subject with creamy paint. Look for the lights and darks, mix the colours you see and put them down simply and boldly. Keep the painting simple. Then use the tip of your brush or the tip of a knife to 'draw' into the paint surface.*

▽**3** *In this detail you can see the way the artist has described the onion using a limited palette of muted colours. The sgraffitoed lines add emphasis. Notice the way the pencil has also been used to draw into the paint, creating a sgraffito line with a different quality. It really doesn't matter what you do as long as it has the desired effect.*

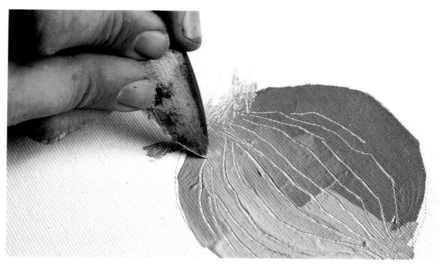

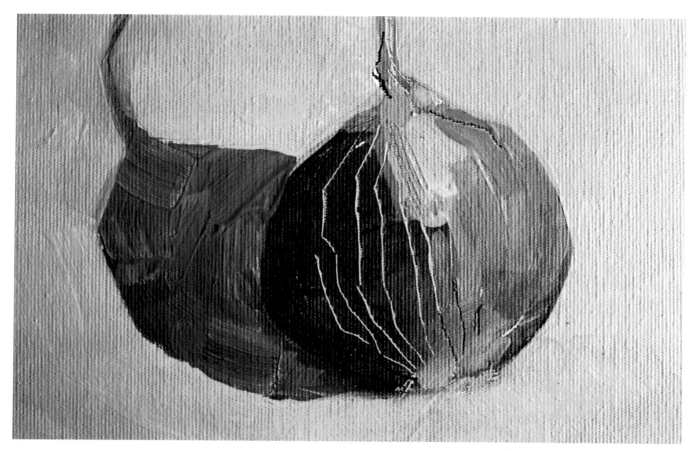

GLAZING

A glaze is a transparent film of colour which tints an underlying colour without obliterating it.

Mixing a glaze

To make a glaze, thin the paint with water or medium. Paint thinned with water will dry to a dull, matt finish. A glaze made by adding gloss or matt medium to the paint will be richer and have more depth, and in the case of the gloss medium it will dry with a slight sheen. Some colours make better glazes

than others. Manufacturers indicate by means of a code which colours are most transparent. So in the Winsor & Newton artists' range phthalo blue and cerulean blue are more transparent than cerulean blue hue and cobalt blue, and would therefore be better for glazing.

Applying glazes

A glaze must be applied over dry paint. Because acrylic dries quickly, you can build up layers of scumbles and glazes in rapid succession. Glazing is a common oil-painting technique, but there the whole process takes much longer because each layer needs several days to dry out.

To use glazes effectively, you should work from light to dark, gradually building up the tone and colour. A glaze of dark colour laid over a paler one

△ **Dark over light**
A glaze of cobalt blue mixed with matt medium was laid over cadmium yellow medium to produce a dark green.

△ **Light over dark**
Cadmium yellow medium mixed with medium was applied over Spectrum red. The yellow slightly modifies the opaque red.

will have most impact, but a lighter colour such as yellow can be used to subtly modify a deep blue. You can even glaze with white.

Using glazes

A glazing technique is ideal for portraits and figure painting, where delicate handling and subtle modulations of colour and tone are important. You could start by blocking in the broad forms with flat, opaque paint, and then complete the painting with layers of thin, transparent glazes which allow the base colour to shine through and give the paint surface a luminous quality.

Successive layers of transparent colour can be used to build up complex and infinitely subtle areas of colour which have a depth and translucency which cannot be achieved in any other way.

Orange: Glazed

▽1 *Choose a single simple household object and experiment with the glazing techniques described. Here the artist has chosen an orange and has set it against a background in complementary blues and blue-greens.*

Start by blocking in the broad forms using flat, opaque colours, diluted with water. Keep the image as simple as possible. When it is dry – a matter of minutes – mix glazes of darker tones, using matt medium, and lay on the darker tones.

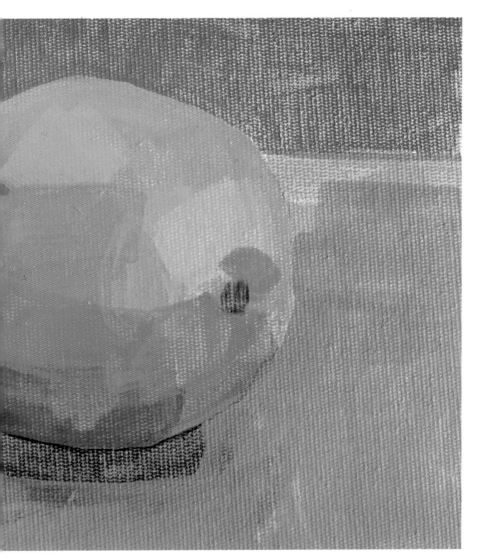

◁2 *The orange is built up from layers and patches of transparent glaze which modify the opaque underpainting. The shadow on the left is a glaze of dark blue.*

51

PROJECTS

COLLAGE

A 'collage' is an image created by sticking paper, fabric, string and printed matter to a flat support. It can be also be combined with other media like pencil, crayon and pastel – in fact, you can use anything and almost everything.

Artists use collage because it is direct and fresh, and provides a splendid way of exploring colour, composition and texture. You can use scissors to cut out bold shapes, or you can tear paper and fabric to create interesting edges. Because you are handling solid objects and shapes, a collage builds up quickly and you aren't tempted to fiddle. You can concentrate on the broad forms and arrangements of colour, tone and texture.

Acrylic is ideal for collage because both the paint and the media are highly adhesive. You can apply paint to the support and simply embed other materials in it. Really heavy or highly textured substances can be glued with texture paste, which is particularly adhesive. Acrylics are chemically inert when dry, which means they won't change colour or become brittle with age, and because they dry to a clear, tough, flexible film they will hold the elements of the collage permanently.

To give yourself more confidence with acrylic, collect together as many interesting materials as you can lay your hands on. Newsprint and pictures from magazines, fabrics with interesting textures and colours, natural materials like leaves and shells, even household objects like egg boxes, milk-bottle tops and buttons can be of interest. You can either make an abstract composition, like the one shown on these pages, or you can make a study of a subject such as a still life or landscape. Look at the collage study of figures in a pool by Stan Smith on page 6.

Above all, be free and enjoy the process.

▷**1** *The artist started with a piece of hardboard and glued coloured papers and scrim to it using acrylic mediums. He painted over the paper and scrim, then tore strips of paper and pasted them on with medium. The red paint was mixed with medium and trickled on.*

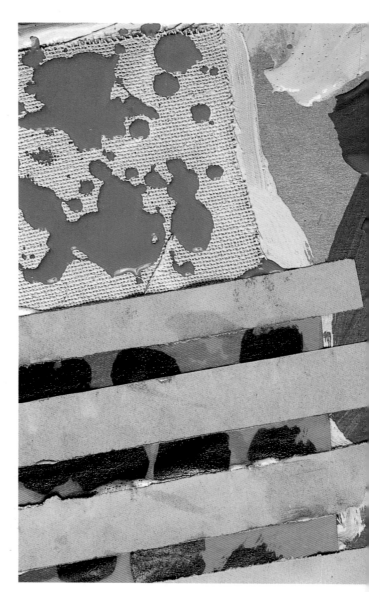

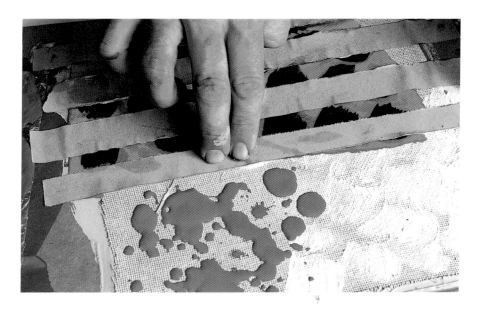

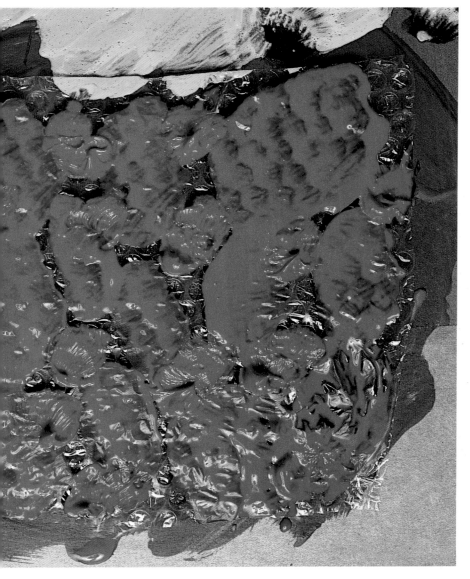

◁**2** *Here red paint has been applied over bubble-pack, creating an interesting patch of texture.*

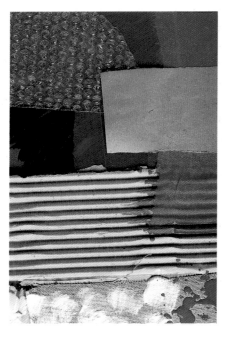

△**3** *Bubble-packing material and pink sugar paper were glued on using the red paint.*

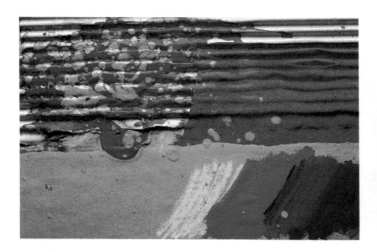

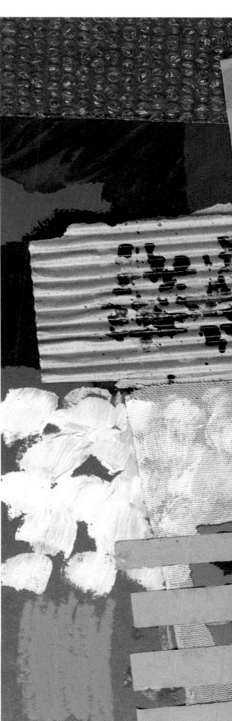

△**4** *Corrugated cardboard was glued to the surface, then some muslin. Paint was painted and trickled on. In the bottom part of the detail you can see yellow soft pastel. The purple is also soft pastel, but it has been blended with acrylic medium.*

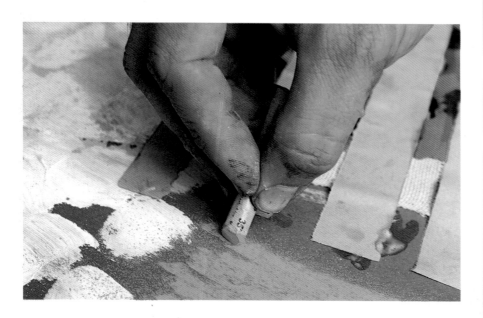

△**5** *Bright-green pastel provides a lively contrast colour.*

▷**6** *The finished collage illustrates just how flexible the medium is. It demonstrates the brilliance and intensity of acrylic colours and the way they can be used on almost any material.*

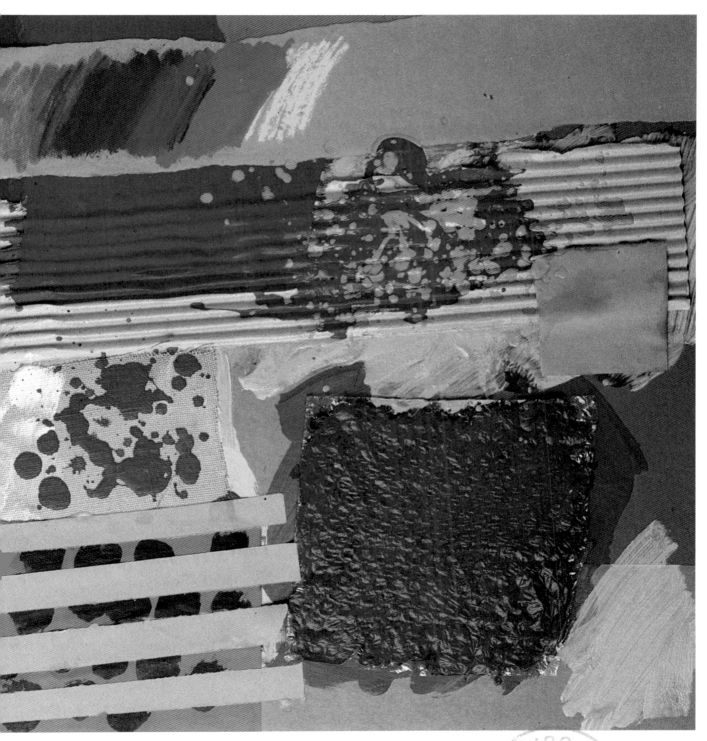

Working in the studio

YOU HAVE by now familiarized yourself with the materials and have some basic techniques under your belt. The next stage is deciding what to paint. Selecting a subject and actually getting started, putting that first mark on a pristine canvas, can be a real stumbling-block for beginners.

The most popular subjects are still life, landscape and the figure, so I've asked three artists to tackle these and the work in progress has been photographed. The idea is to let you look over the artists' shoulders, to see how they work and to share their thought processes. I am not providing 'recipes' or foolproof formulae; this is a discussion of approaches to painting in general and the subject in particular, so that you can evolve your own solutions.

The photographs are extensively captioned, but space is necessarily limited and you'll learn a great deal by comparing one stage with another, noting the way the composition changes and the paint surface builds up. Don't copy the projects. You will find it much easier and more enjoyable to set up an equivalent subject, and you will certainly learn more that way.

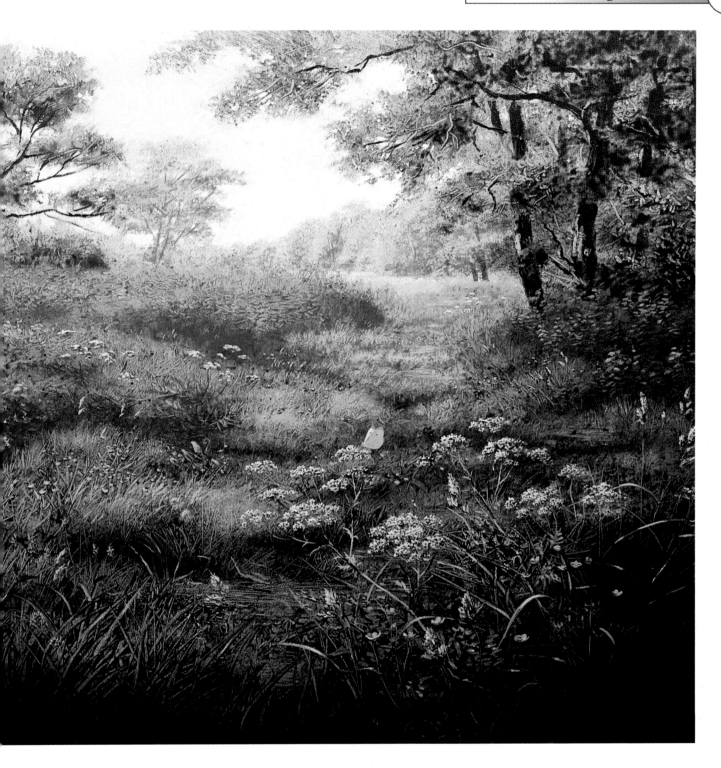

△'Woodland Clearing – July' by Richard Tratt is a romantic evocation of the English countryside. The artist is driven by a desire to record wildlife habitats and to capture the essence of these wilderness places. This painting was worked up in the studio from acrylic sketches made in the field. He used gloss and gel media together with a retarding agent which allowed him time to work into the paint surface with a variety of techniques including sgrafitto.

PROJECTS

STILL LIFE

A still-life group can be assembled from almost anything – pots, old tools, kitchen utensils, pebbles and driftwood. In this case the artist, Stan Smith, sought inspiration in the local greengrocer's shop. Most shoppers are looking for quality and ripeness; Stan was looking for colour and shape, for the most picturesque fruit and veg. And what a gorgeous subject this is – exciting colours, marvellous textures and a variety of related shapes.

The paintability of the subject shouldn't be overlooked, for while it is true that anything can be the subject of a painting, and it is sometimes necessary to force yourself to deal with a subject which doesn't engage you, it is also true that a subject which 'grabs you' will be fun to paint and hold your attention.

The advantages of still life
Still life provides the artist with limitless opportunities and has many advantages. First and foremost are the ease with which a subject can be assembled and the degree of control which you have over the content. Make a selection of interesting objects and arrange them, looking for the way shapes and colour play off one another. Take items out and put others in until you are satisfied with the whole.

Lighting the group
You will need to light the group. Lighting can change the appearance and mood of a subject – think of how important it is in the theatre. So, for example, while a direct light from the front of the group will flatten forms, a strong side light will cast intense shadows, emphasize shapes and create drama. Experiment with different lighting arrangements. Perhaps you could place the group near a window to exploit natural light, or try bouncing a spotlight off the wall behind to create a soft, indirect background light.

Selecting a viewpoint
Before beginning to paint, decide on a viewpoint. Do you want to look down on the arrangement or view it at eye-level? Move around and make some sketches to see what works best. How much of the subject are you going to include? Will you stand back from the group and include a lot of the surroundings, or will you crop in close to frame the subject tightly? Now you are ready to start.

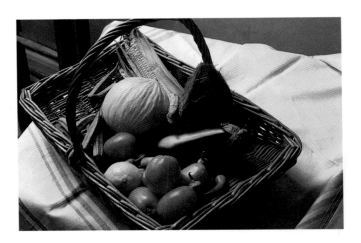

△1 *The vegetables and fruit were chosen for their colour, texture and shape. The strong rectangle of the basket provides a linear element which contrasts with their curving forms. The wickerwork sets off the smooth textures of the fruit and vegetables and echoes the rougher texture and neutral ochres of the coconut.*

▽2 *The support is heavy, unstretched watercolour paper. The artist started by drawing with thinly diluted paint, then blocked in the broad forms. He concentrated on midtones, so that he could build up the colour and add lights and darks later.*

▽ **3** *In this study Stan uses a traditional approach, laying in an underpainting and building up from that. This is a good way of working: you start with approximate shapes and colours, tightening up the image and becoming more accurate with colours and forms as the work progresses. Stan calls it 'thinking for tomorrow', although with acrylics you can build up several layers in a single day and 'think for today'. In this detail you can see how bold the underpainting is. The acrylic paint is opaque in some areas and transparent in others.*

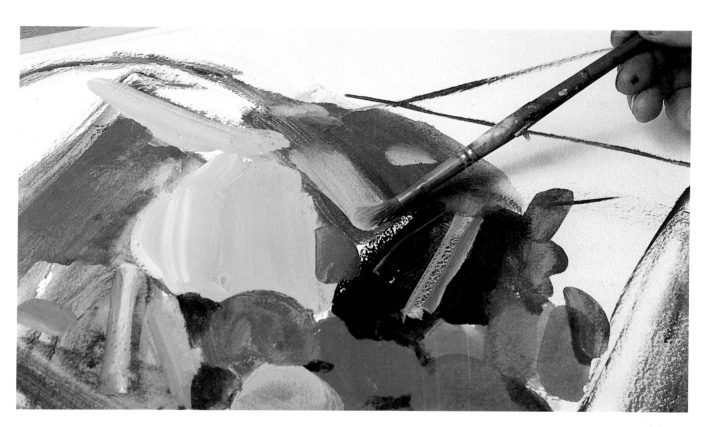

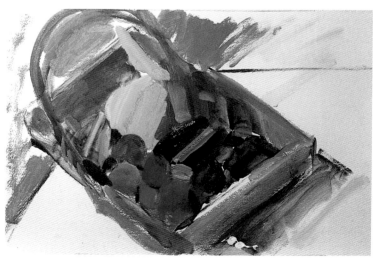

◁ **4** *The basket and fruit have been blocked in. There is an indication of the dark tones in the background and the shadow cast by the basket. This is a good point at which to stop and assess progress. Stand well back from the painting so that you can see both it and the subject. Study both carefully. Half-closing your eyes will help you concentrate and will simplify the tonal arrangements. Do remember that you can make a statement and adjust it at any time. Don't feel constrained by what you have put on the canvas.*

▽5 *Stan washed in the tablecloth using cool greens and blues. The mid-browns of the background have been overlaid with glazes of neutral colours which link it to the rest of the painting. He works over the whole painting, adding glazes of colour on the aubergine, for example. Keep the whole surface of the painting going at once – if you concentrate on one area, it will become overworked and tight and this will throw the whole painting out of kilter.*

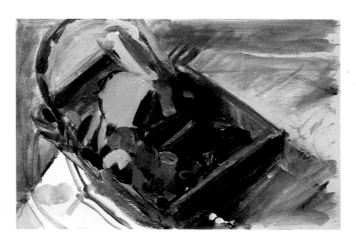

▷6 *Yellow ochre is scumbled over the coconut and the warm shadows of the melon. The paint is loosely applied and does not quite obliterate the underlying layers. Complex films of thin colour are beginning to build up.*

◁**7** Compare this with the previous picture to see how the paint surface is building up. Colour doesn't exist in isolation; we always see it surrounded by other colours that modify it. So a lemon yellow which looks cool beside red will look warm beside blue, and an adjustment in one area of the painting will require an adjustment in another part.

In this painting the artist hasn't used any black. For the dark of the aubergine, he uses a purple-blackish colour built up using about eight variations added a touch here and a touch there. When he finds a similar colour in a shadow on the other side of the picture he relates it back, so that colour dances across the paint surface, linking the whole.

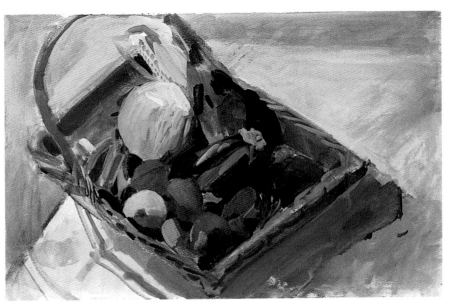

◁**8** The artist has used a range of browns and blues to lay in the background, and over this he has scumbled white broken with blue and brown in the area of the tablecloth. White is a deceptive colour in that it is never just white. Put several white items side by side – a porcelain cup, a sheet of white paper, a white cloth – and you will see that they are all different. White picks up surrounding colours, so pure white pigment used to paint a white object will look very unconvincing.

Stan has started to add details like the woven texture of the wicker and the blue border on the tablecloth.

▷**9** White paint is scumbled on, leaving the darker white underneath to stand for the crease in the cloth. When adding a detail like this, make sure it is 'useful' to the composition.

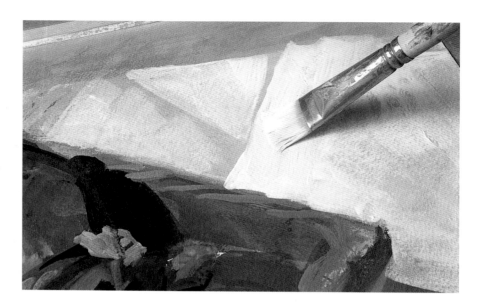

▽**10** Brushwork gives character to a painting and is often descriptive. Notice how the brushmarks follow the curving forms of the fruit and plaited strands of the basket.
 Acrylic can be used light on dark as well as dark on light. Here highlights are added in thinned paint, which allows the colour beneath to show through.

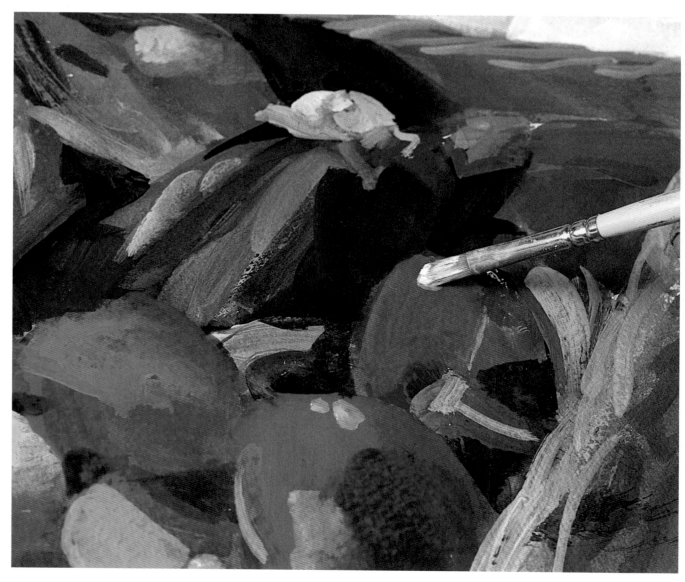

▷**11** *Compare this with the picture on the previous page and you will see the way in which the wickerwork has been developed by adding light and dark tones on top of the mid-tones.*

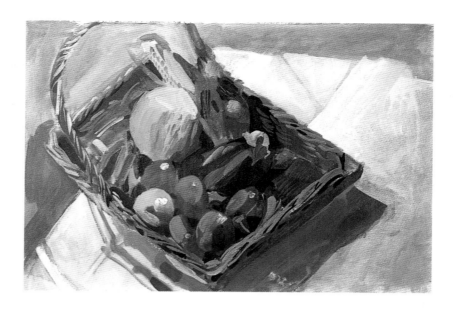

▽**12** *Now compare this with picture 11 and you will see that the whole image is being tightened up. Look at the lemon on the left, for example. Separate patches of colour have been over-glazed with subtle colour that pulls the whole thing together. On the coconut, texture has been added to describe its hairy husk – some of the colour has been sgrafittoed on with the tip of the brush. The ridged surface of the melon has been implied, but the artist has not lost its roundness. There are bright highlights on the top surface where it catches the light, with darker tones where it turns away from the light.*

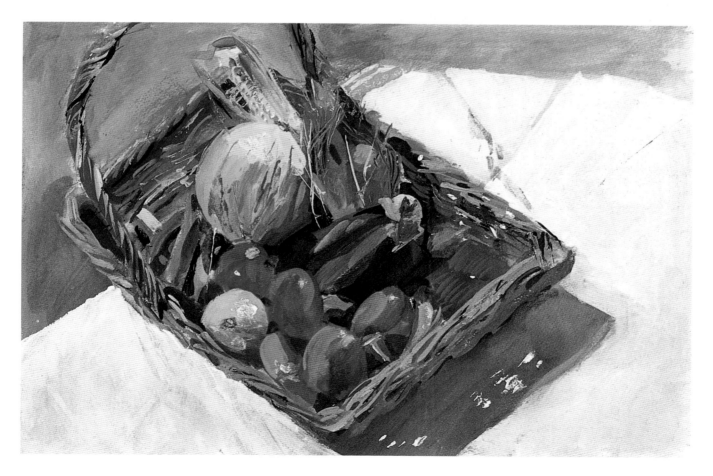

▽ **13** *The artist feels the silhouette of the basket is important and should be uncluttered, so he paints out the blue border and repaints it near the corner using a knife. (He removes it entirely in the final painting.)*

 The white of the tablecloth is warmer on this side because it is close to the viewer.

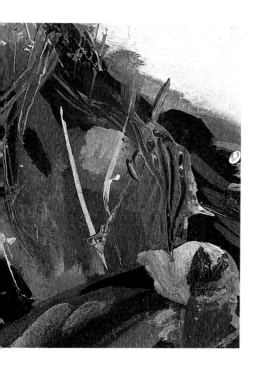

◁**14** The layers of scumbles and glazes give the paint surface great depth and contrast with patches of crisp, opaque colour. The paint surface is an important aspect of any picture and can be enjoyed for its own sake as well as for its descriptive qualities.

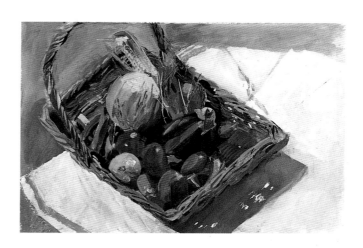

△**15** The tipped diagonals of the basket give this painting enormous energy and drama. The negative shapes are as important as the positive shapes. Look, for example, at the white geometric shapes of the cloth trapped between the edges of the basket and the edge of the painting. Half-close your eyes and you will see that they stand out as distinct elements in the composition.

Another linking theme is provided by the warm umbers and siennas that occur across the painting – many of the greys, even the blue-greys and the shadows around the basket, have umber in them.

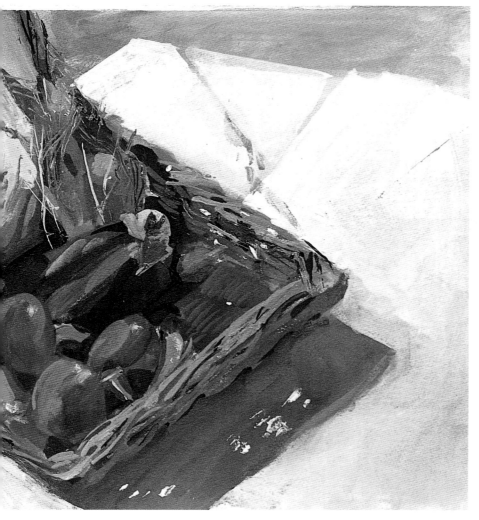

◁**16** Stan made a final adjustment to the painting. He removed the blue stripes altogether because, when he assessed the work, he decided they were unnecessary and intrusive. The richness of the contents of the basket and the basket itself didn't need this complication and the strong diagonals of the basket, worked better on a simple, unobtrusive background.

VIEW THROUGH A WINDOW

In Chapter 6 I introduce you to landscape painting and the problems and pleasures of painting out of doors. But you don't have to trek off to some remote beauty spot to paint a landscape. You'll find one right outside your own front door or window, and you needn't even step outside. You can paint a view through a door or a window in the comfort of your own home. The advantage is that you don't have to pack your kit or plan an expedition – which means that you can leave your picture and return to work on it over a period of days.

An 'indoor' landscape

Look around your home and you'll find that every window and doorway frames a different picture of the world, each with special qualities and problems. From windows high up, for example, you get startling perspectives – a bird's-eye view of the world. In the city you'll find a panoramic vista of roof-tops, a repeating jigsaw of geometric shapes – dark and muted in dull weather, vivid and reflective in bright sunlight, with deep shadows between buildings; glistening on wet days, a blanket of pearly greys and sparkling whites on snowy days.

The 'indoor' landscape presents many of the same problems as an 'outdoor' landscape. You will still be subject to the vagaries of the weather and the changes wrought by the progress of the seasons. The light will change, not just from season to season, day to day and hour to hour, but even from minute to minute. You will have to find a way of capturing and encapsulating those variables.

The inside–outside dimension is an important aspect of the subject. Artists have always been fascinated by the idea of the viewer as voyeur, peeking into a room through an open door, looking out on the world through an open window. Most paintings freeze a moment in time, but the architectural frame seems to emphasize the quality of time standing still, of the world observed.

The challenge of the everyday

And finally you have the thrill and the challenge of finding and describing the special in the everyday. A view that is so familiar that you've ceased to notice it suddenly takes on new significance. This is the real challenge and pleasure of any painting – the ability to look at the world around you and to see it afresh with artist's eyes. And then to share your vision with others, so that they too can find pleasure and interest in apparently mundane things.

△1　*This is the view from the first-floor window of a house in Brighton. Spatially there are three planes: the balcony with the wrought-iron railing and the pots of geraniums, the tree beyond, and beyond that the street and a terrace of houses. Start by making several sketches of the subject. These will familiarize you with the subject and help you decide what to include and how to frame the image.*

△2　*Stan Smith drew the main elements of the composition on to the canvas with charcoal. The verticals and horizontals of the glazing bars provide a useful grid. To make an accurate drawing, compare and contrast shapes and spaces, measuring one element against another. In this case you would compare the height of the railing with the height of the tree, and judge the angle of the road against the vertical of the tree.*

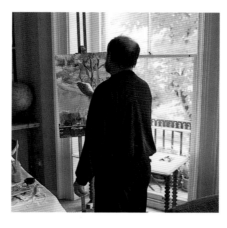

◁**3** *Stan blocked in the broad areas of colour using a limited palette of colours and thin, washy paint.*

◁**4** *Working at an easel gives you great freedom of movement so that you can step back from the painting and review progress. Try to see the painting as a whole and don't become too absorbed in one passage. Keep your eye on both the subject and the painting, constantly looking from one to the other, judging, assessing and making adjustments.*

▽**5** *This picture was painted on a sunny September day. Stan used thin layers of paint and light colours for the underpainting in order to capture the brightness of the outdoor light and of sunlight filtered through bright-green foliage. With a bold, impressionistic technique he uses dabs and dashes of mixed greens to describe bunches of leaves. Foliage is difficult to paint. Don't deal with it leaf by leaf. Forget what it is and paint exactly what you see – the result will be much less confusing.*

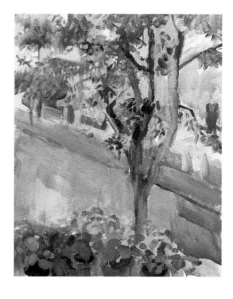

△**6** *There is a lot of what Stan calls 'travel' in this painting. The eye is led in and out of the painting, as well as across the picture surface. The plants at the bottom of the picture establish the front plane, the tree provides a strong vertical element and the oblique of the road leads the eye across the picture surface.*

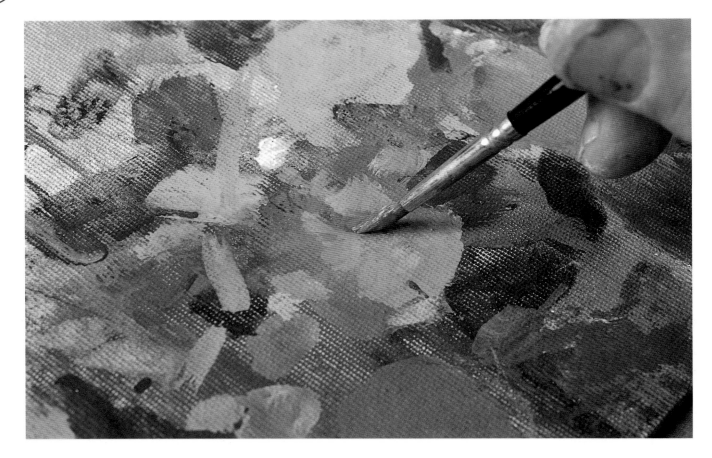

△ **7** *This detail shows you just how complex the paint surface is close to. The foliage of the plants is built up from lots of greens; even the geranium flowers are made up from several tones of pink.*

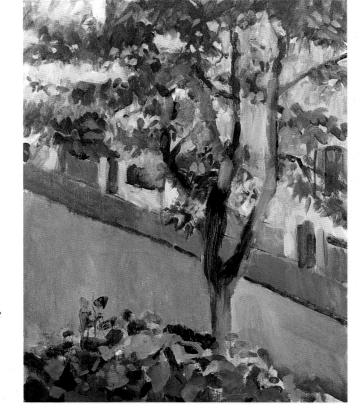

▷ **8** *The artist implies the architectural forms across the street but avoids too much detail which would draw the eye. Everything has to find its correct place in space if the picture is to be spatially convincing. Tone is important in this context – light tones sit back in space and dark tones come forward. Warm colours also sit forward, so the bright reds of the geraniums bring them to the front of the picture plane. If the geraniums were on the far side of the street, you would use a more muted shade of red, even if the plants were exactly the same colour.*

▷**9** The details of the railings are added at the very end, using black mixed with blue. Don't be tempted to fiddle or draw them with a ruler; that way they won't harmonize with the rest of the painting. Work freehand with a brush and find an approximation for them.

◁**10** When painting a tree, try and find a generalized way of describing it. Look at the overall shape of the crown of the tree. Within that you will find large clumps and clusters of leaves. Light shines from above, illuminating the tops of these forms, leaving dark tones underneath. Half-closing your eyes will help you to simplify the subject. Then paint what you see, remembering the way in which light reveals the solidity of forms.

The finished painting is impressionistically rendered. It has a light touch and a bright, summery feel. Deciding when to stop is an important part of the painting process. It would be easy to overwork a subject like this and lose that attractive freshness and spontaneity.

FIGURE IN AN INTERIOR

Painting people, whether figure studies, portraits or self-portraits, is one of the most fascinating, rewarding and revealing of all artistic endeavours. But it is a subject which most artists, even those who are skilled and experienced, approach with trepidation. There is a tendency to be awed by the subject and to be over-concerned with achieving a good likeness. This concentration on the finished image can make you nervous and tentative, and distracts from the process of picture-making. The subject is challenging: you have to render the subtleties of flesh tones and the solidity of the underlying skeletal structures, while at the same time capturing a sense of the life beneath the surface.

The approach

Treat a figure study or a portrait as you would any other painting. Put from your mind the fact that this is a fellow human being, a friend or a relation. Concentrate instead on the compositional possibilities – the way the figure relates to the background, the colour relationships, the tonal qualities and the contrasts and harmonies which can be exaggerated or emphasized to create interest.

Posing the model

Persuade a friend or a member of your family to sit for you. Find a location in which they are comfortable and where you have plenty of space in which to work.

Make sure you have good light – both on the canvas and on the subject. Lighting affects the mood and the tonal values of the study.

Experiment with different poses until you find something that interests you. Ask the model to sit, stand, lean on his or her knee, read a book, look left, look right, and so on. Look at what they are wearing. Are the colours interesting? Do you like the way the fabric hangs? Would a bright-red shawl add a splash of accent colour? Perhaps a hat would be interesting.

Think about the surroundings. Do you want to place the model against a plain background or a busy one? Do you want them relaxed in an armchair or upright on a straight-backed chair?

Preparatory drawings

Make a series of quick sketches in which you analyse the composition and decide how to frame the image – what to include, what to leave out, which viewpoint to take, and what shape the picture will be. Now you are ready to start.

△**1** *The artist, John Crawford Fraser, spent time exploring different poses and backgrounds with the model. To emphasize the drama of the sitter's all-black clothing, he simplified the background, draping plain cloth over the sofa and covering the patterned carpet with a rug in neutral stripes.*

▷**2** *He made quick sketches of different poses. These exploratory drawings help you to understand the pose and to 'see' the possibilities of the composition.*

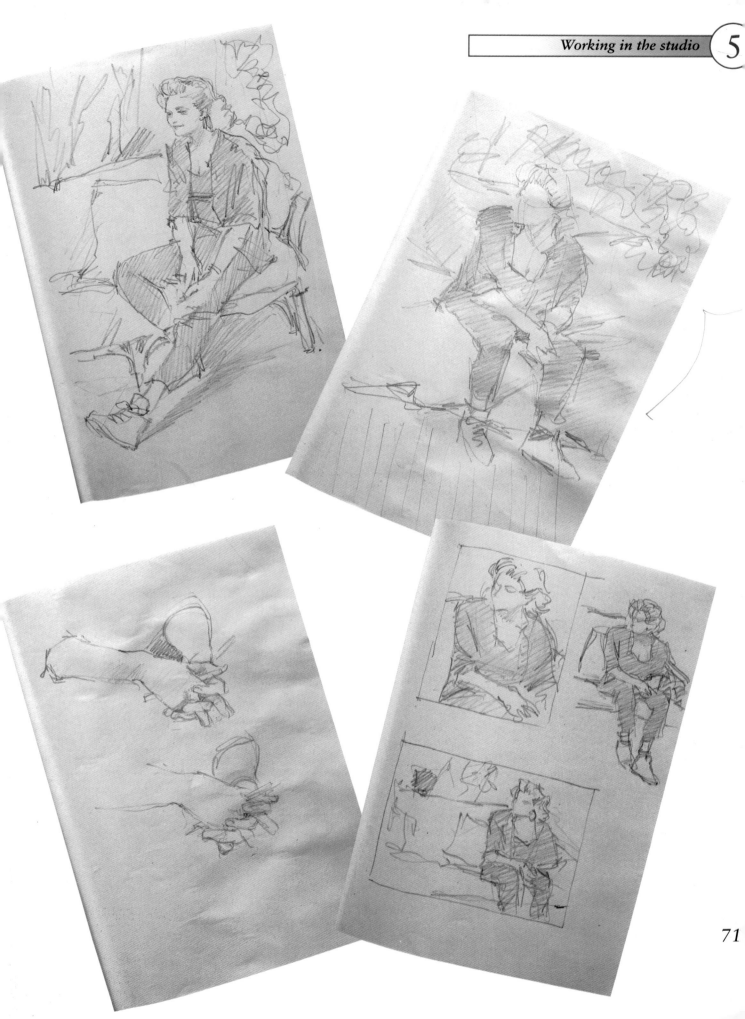

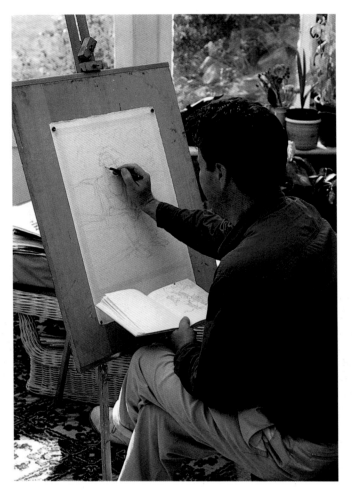

▽**4** *A blank white surface can be daunting, so the artist has toned the paper with a wash of raw sienna and yellow ochre. This is a useful approach. It gives you a mid-tone from which you can work backwards and forwards, applying dark tones and light tones, so that the image begins to come together early on. Don't worry about achieving an absolutely flat wash – the uneven colour will add interest to the final picture.*

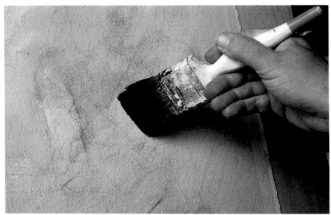

△**3** *The artist chose a sheet of heavy Bockingford watercolour paper – 300 lb (640 gsm) – with a rough surface. Because the paper is so heavy, it does not need to be stretched. He drew in the broad outlines of the figure, looking for verticals and horizontals, and comparing one shape with another. Draw exactly what you see, rather than what you 'know' to be there. Work quickly and don't try to produce a finished drawing – you can firm up the details of the image as you paint.*

△**5** *Here the paper is scored with a knife, breaking up the surface to draw attention to the tactile qualities of the paper and also to describe the branches of the hedge seen through the window in the background.*

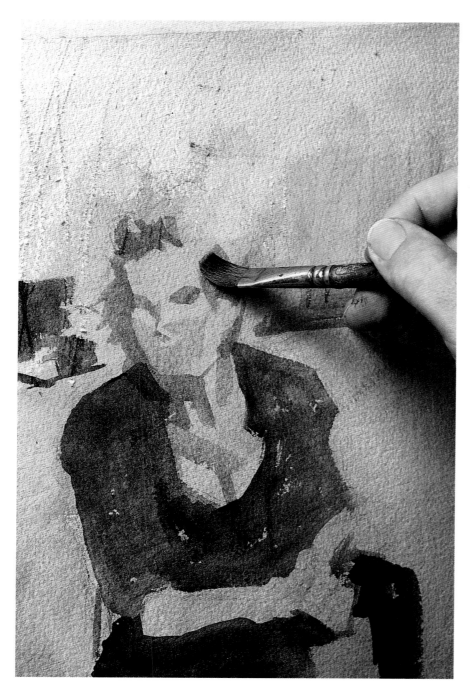

▽**7** *Here you can see the way in which starting with a good mid-tone allows you to pull the image together very quickly. The artist has laid in the darker tones very broadly, but already the image reads as a seated figure within a loosely described setting.*

△**6** *The broad forms of the figure were blocked in using a dark brown mixed from burnt umber and Prussian blue. An artist never starts with black, because it kills colour and things are very rarely really black anyway. Here, for example, sunlight shining through the window made the black clothes look warm brown.*

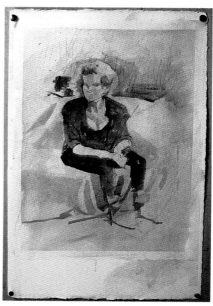

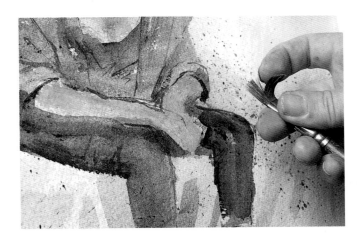

△**8** Here the artist spatters the painting with the burnt umber and Prussian blue mixture. This softens the image and adds texture.

▷**9** Using a small sable brush, the artist draws in fine details – the eyes, the hair, the nose and the mouth. Try not to be too pernickety. Draw the forms, but smudge them with your finger or a bit of tissue to prevent them looking more resolved than the rest of the painting.

▽**10** The background was washed in with cadmium green light, a bright apple green, toned down with Payne's grey. You can see the way this colour has settled into the scoring marks. Using a painting knife, he then applies a yellowy-green, mixed from cadmium green light and cadmium yellow. Crisp dabs of opaque colour describe the leaves of the tomato plants behind the sitter.

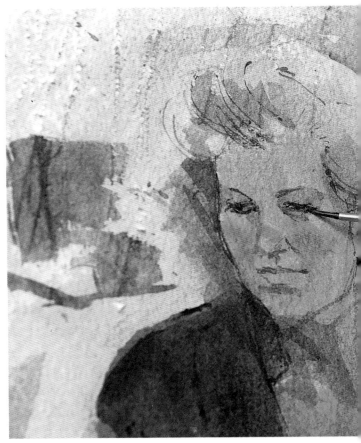

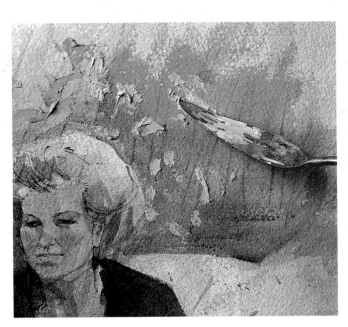

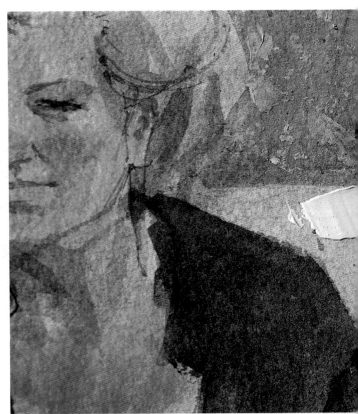

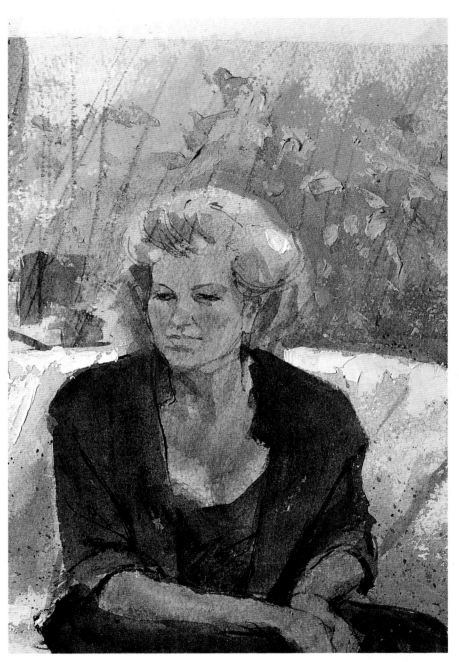

◁**11** *Crisp white paint is used to suggest the dense woolly texture of the blanket, at its lightest where it catches the light on the back of the sofa.*

△**12** *The black of the model's clothes has been given more substance by washing on more of the dark-brown mixture, using this darker tone to define the forms. You can see these darker tones where the upper part of the leg meets the sofa, and on the left leg.*

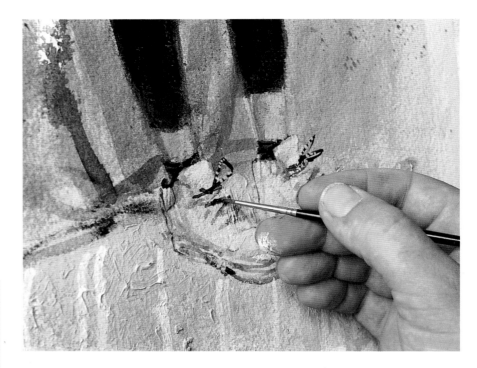

△**14** *Transparent and opaque white are used for the trainers. Here the artist draws in the laces with thinned black paint.*

▽**15** *The low-tack tape used to mask the edge of the painting is removed, leaving a neat, crisp edge.*

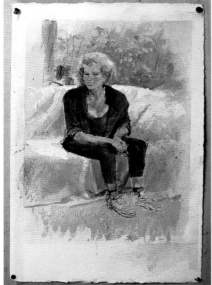

△**13** *Acrylic allows the artist to use luminous glazes of colour over most of the painting, contrasting this with creamy impastos in others. An opaque mixed-grey paint is laid on in swathes to describe the slubby texture of the rug on the floor, with fine lines of thin, cream-coloured paint for the woven motif. Touches of opaque white tinted with a little permanent rose are used on the fingers.*

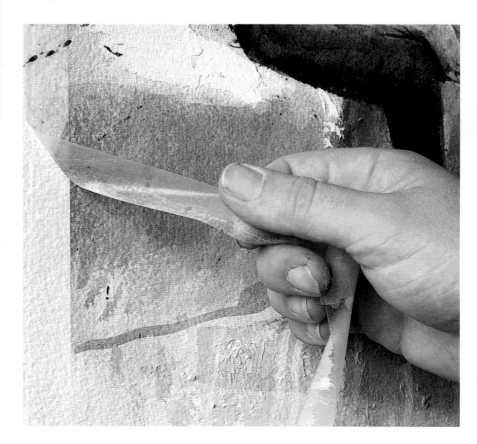

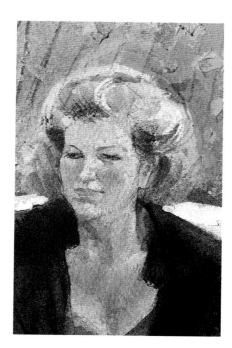

△**16** *Skin tones must be fresh and lively. The artist achieved this by laying on a series of transparent glazes. He used several mixtures. In the warm areas on the chest and forearms he used raw sienna and cadmium red medium, with glazes of pure cadmium red in some areas, like the fingers.*

▷**17** *The artist completes the picture by adding opaque highlights on the flesh and hair, and green mixed with white for bright, sunlit areas in the foliage. The composition is simple, with the figure placed centrally. The artist has used a limited palette of cool greens and warm neutral beiges and greys, with rich, velvety black creating a dramatic focus in the centre of the painting. The texture of the thick watercolour paper, the shimmering quality of the washes and the succulence of the creamy impastos give the painting a lively and pleasing surface.*

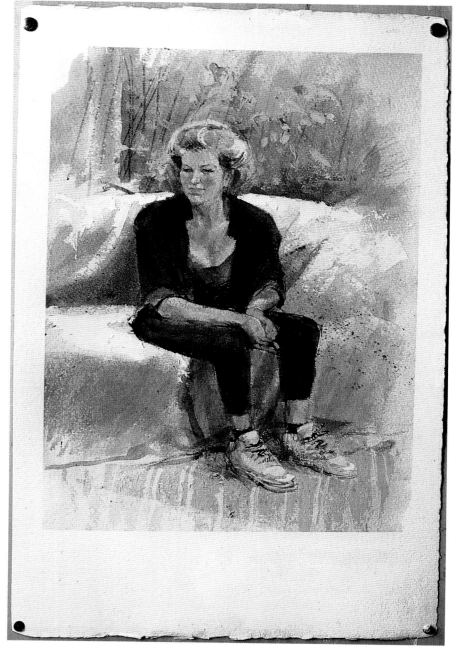

PROJECTS

'THE WAVE'

In this large painting – 55 × 70 inches (140 × 178 cm) – the artist, Ian Sidaway, has taken an apparently simple subject and created a dramatic image. He does this by means of a carefully organized composition. The subject is deceptively simple – four figures set against a large expanse of blue water. However, a great deal of thought has gone into the way that the individual elements are arranged within the picture area. The artist has 'composed' the image, just as a composer 'composes' a piece of music.

Looking for pattern

The second element in the picture is the pattern-making qualities of the water's surface. The artist focuses on this aspect of the subject, selecting, editing and exaggerating to create an interesting and satisfying image. He combines compositional rigour with freedom in the way he approaches the subject and handles the paint, using several acrylic media to change the way the paint moves on the canvas and the quality of the paint surface.

Working from photographs

The inspiration came from a series of four photographs which he worked up in a pencil drawing, taking elements from each picture, arranging and changing them to suit his intentions.

There is considerable, and unjustifiable, prejudice against using photographs as the basis of a painting – you will no doubt have heard at some time or another that it is not the correct thing to do. But far from it! Most artists use photographs at some time, especially portrait-painters and illustrators. When photography was introduced in 1839, artists were among the first to realize its potential. Corot (1796–1875) used blurred images to imply motion – an effect gleaned from photography – and Degas (1834–1917) exploited 'snapshot' qualities in his compositions, cropping figures in a way which would have been considered most odd before the

camera made this type of apparently random composition commonplace.

What you shouldn't do is copy photographs. There really isn't any point and you deny yourself creative control. The best way to use photography is as a jumping-off point for an idea, or as a reference for details like cloud formations, architecture and facial characteristics. To ensure that your personal vision prevails, use several photographs, supplemented by sketches and colour notes, and even images taken from books, magazines and newspaper. In this way, photography can be a useful and richly rewarding complement to the creative process.

◁**1** *The composition was worked out in a detailed pencil drawing. To transfer this to canvas, the artist sketched a grid over the drawing and a larger grid with the same number of squares over the canvas. He was then able to transfer the image to the canvas square by square. Here he draws the main elements of the picture, using a dilute solution of Payne's grey and water.*

△**2** *A different linear quality is introduced by using a mask to define the limits of the wave, rather than a drawn line. Brown paper is torn to the shape and size required and taped to the canvas. Masks can be cut or torn, or you can use special masking fluid designed for use with watercolour. This is applied with a brush and dries to a rubbery film. It is removed by gentle rubbing with the fingertips.*

◁**3** *The sea was laid in using a mixture of cerulean blue, Spectrum yellow, a touch of Payne's grey, and titanium white. To extend the paint and increase the flow he added copolymer emulsion, an acrylic medium produced by Spectrum.*

▷**4** *The torn-paper mask was removed, revealing a crisp white shape. Using the same base colour, the mid-toned pattern of wavelets was painted. The artist used freehand brushstrokes in some areas, but in others he used a loose mask of torn watercolour paper.*

▽**5** *The figures were painted next, using raw umber and burnt umber, plus mixtures of each with white. For the dark reflections of the figures he used cadmium red, Spectrum yellow, cobalt blue and titanium white.*

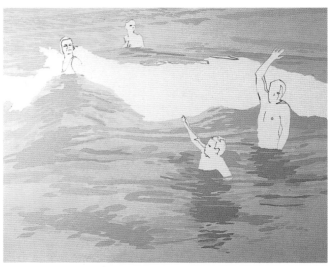

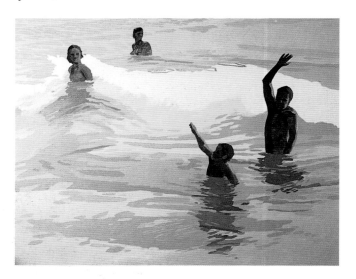

▽**6** *Using a range of colour mixes the artist continues to elaborate the water surface, softening the forms of the waves. A light greeny-blue mixed from cerulean blue, Spectrum yellow and white is used for the lighter sea passages, and to highlight the little wavelets. He then returns to the large wave, which dominates the painting. Using a piece of torn watercolour paper as a mask, he reworks that area. He mixes paint with medium and uses vigorous brushwork and spattering to capture the texture of foaming water and spray.*

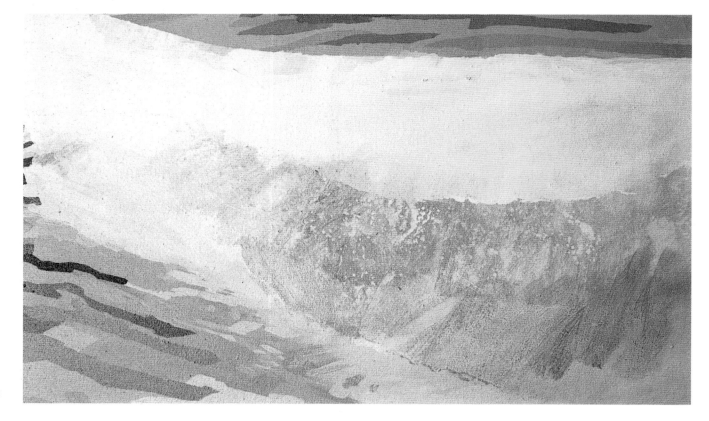

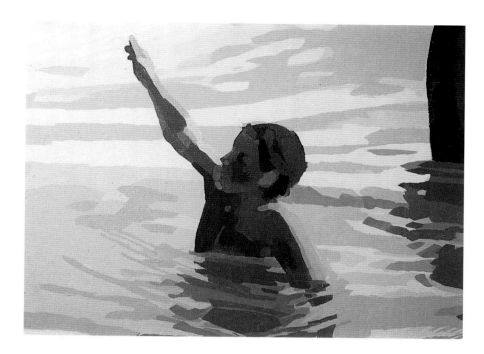

▽7 When painting figures in a large composition such as this, look for the broad forms – the lights, the darks and the mid-tones.

▽8 In this understated work the artist has relied on a solid composition to hold the painting together. He has explored the pattern-making qualities of the sea's mobile surface and the textural qualities of waves and breaking water, giving the painting a satisfyingly abstract quality. An apparently simple subject has as much to offer as more obviously complex subjects.

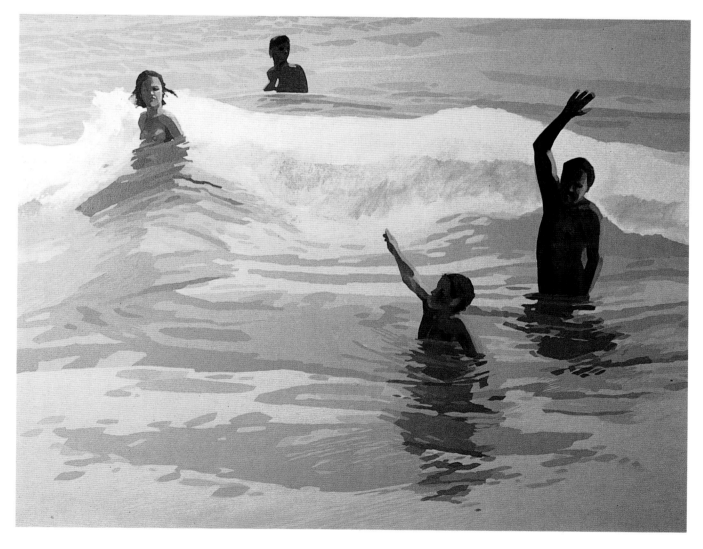

PROJECTS

FIGURES IN A LANDSCAPE

Artists inevitably find that certain subjects interest them more than others. Sometimes a subject will absorb them for years, even for a lifetime. They return to other subjects at regular intervals, trying new approaches, exploring different solutions. The human figure has always absorbed artists, probably because as human beings we never cease to be fascinated by ourselves and our relationship to others.

The artist Stan Smith has long been concerned with the problems posed by painting the figure, and returns to the subject again and again. He works from life, from his huge collection of sketchbooks and drawings and also from memory. An artist never stops collecting data. Even a trip to the shops can trigger an idea or supply a possible solution.

Recently Stan has been using collage, acrylic and gouache to develop these themes. In particular he is interested in using the paint to create a single, columnar, monumental form which resolves itself into a group of figures. These paintings have a strong abstract quality, but are nevertheless figurative, an ambiguity which creates energy and tension.

Using sketchbooks

Use your sketchbook to gather together material for a study. An artist's sketchbook is one of his or her most important tools. It can be a diary, a notebook, a place to work out ideas or experiment with materials. Get used to carrying one around with you, and jot down sketches every day. Don't worry about these drawings being 'good' or 'bad'. They are not finished images and you'll be amazed how vividly even the scrappiest notes will recall an episode or an image.

Select a subject such as children playing, people at a bus-stop, or a market scene, and collect material over a few weeks. Then work this up into an image

in the studio. Remember, it is the process that is important. Be prepared to rework the composition and make changes. Respond to the image on the canvas and let the paint talk to you.

A point of departure

A painting is a summary not only of what you see but also of what you feel and think about what you see. There are no end of visual games that you can play – with space, colour and texture. The best work is made when you explore the boundaries, take risks and treat the image as a point of departure rather than as a destination.

On this page there is a selection of studies in which Stan Smith explores a single theme – a figure or figures in water. He is concerned with the way figures can be related in a composition, and tries different formats and shifts the figures around the picture area, treating the reflected images as positive elements. He uses a variety of media, including gouache, acrylic, collage and inks.

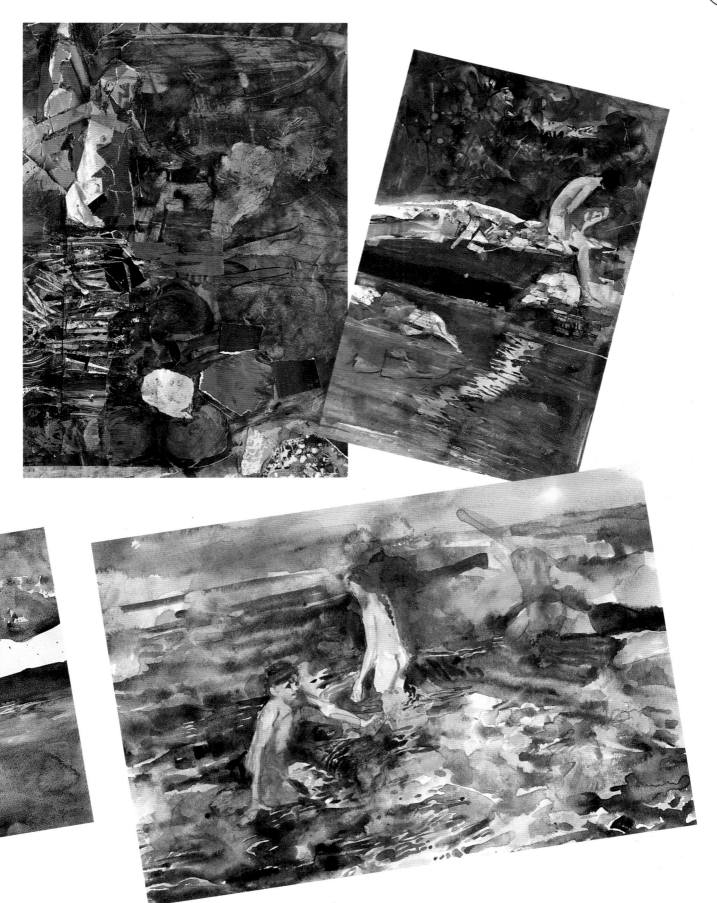

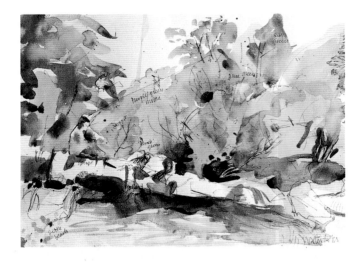

◁**1** *Stan made this sketch on location using Biro and watercolour. The artist scribbled down comments about colours and tones, and physical descriptions like 'pebble beach' and 'waterfall' – anything to act as an aide-mémoire later on.*

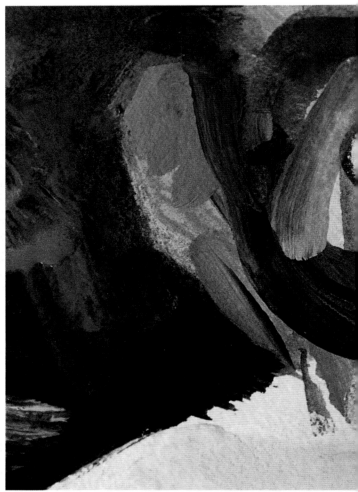

△**2** *In developing this picture the artist is creating something totally new in the studio from reference material which he has collected. Using this sketch plus a couple of those on the previous page as a starting-point, Stan flooded on paint, working loosely and quickly, letting the image emerge from the paint. The support is watercolour paper, which is absorbent. At this stage he wants to establish broad colour arrangements and tonal values. He is looking for a generalized feeling and lets the 'paint do a bit of talking'.*

▷**3** *The paint layers build up with washes of thin opaque colour over the initial transparent layers. He works from the darks towards the lights, laying in a base on to which he can work later, 'painting for tomorrow'.*

Play with the materials and let them contribute to the image.

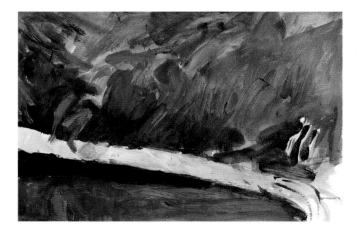

▽ **4** *The figure is treated in an impressionistic way. Thick impasted paint captures the solidity of rock and provides a contrasting texture.*

▷ **5** *Be aware of, and sensitive to, the unique textures and qualities of materials. The water is built up from overlaid colour. For the bright greenery by the waterside, the artist has invented a variety of colours and brushmarks. The rocky outcrop evolves in the same way.*

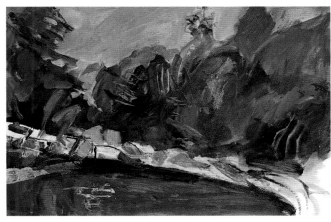

▷**6** *Stan continues to develop the whole picture surface. Here he modifies the green foliage with a wash of blue.*

▽**7** *Creamy white paint is used to add substance to the rocks.*

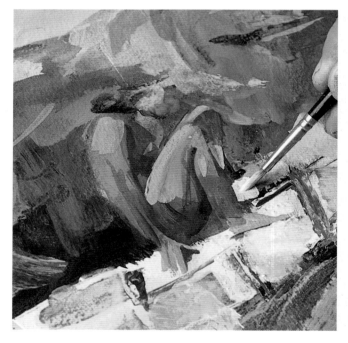

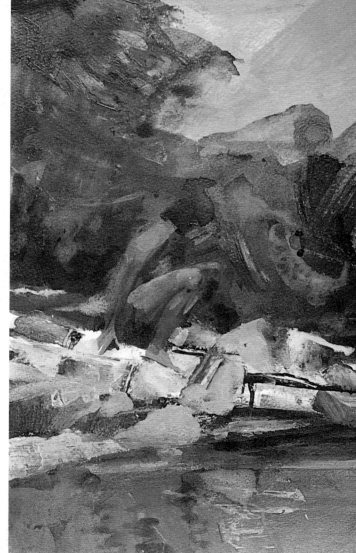

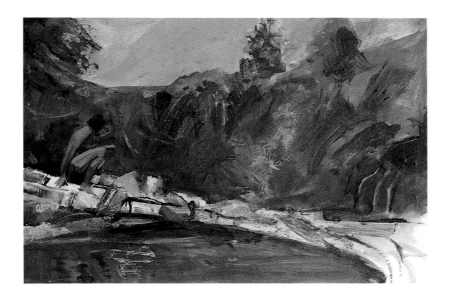

◁8 The artist has captured the rhythms of the original sketch, but he has moved on from this image to create a completely new one. The quality of the paint surface, and the description of the foliage in particular, evolve from the character of the paint itself. The artist doesn't work to a formula, although experience means that he can generally anticipate what will happen. Nevertheless, it is a process of exploration.

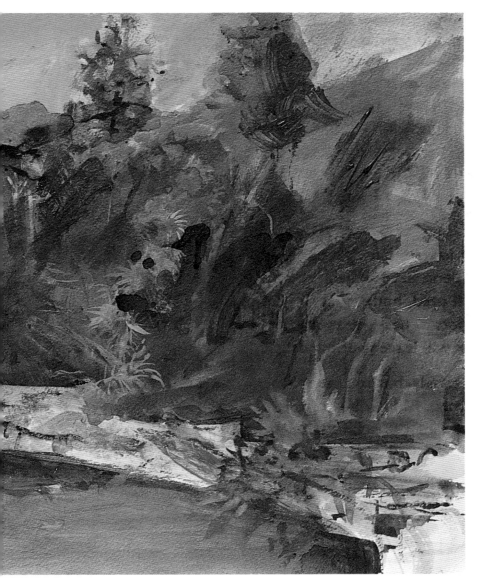

◁9 Stan left the picture overnight, then studied it again. He decided that some features, such as the rocks, seemed less convincing than the figure, and that there was a lack of variety in the colour of the foliage. Nor did he like the regular rhythms of the silhouette of the foliage seen against the sky. He went back to the painting, working over the entire surface, paying particular attention to certain areas – adding more greenery in the right foreground, for example. It is helpful to leave a painting so that you can come back to it with a fresh eye. Most artists live with their paintings for a while before they consider them finished. Sometimes they'll catch sight of a painting out of the corner of their eye and a tiny but essential adjustment will become obvious.

Working out of doors

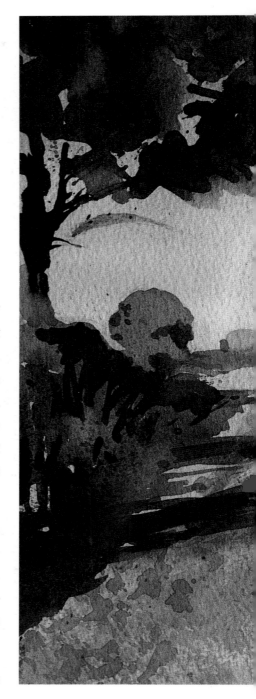

LANDSCAPE PAINTING is fascinating and difficult but very rewarding. In dealing with a landscape, one of the first problems that confronts the artist is where on earth to start. Experienced painters have evolved their own selection processes but for the beginner it is a real problem. A viewfinder will help. Cut a frame 4 × 6 inches (10 × 15 cm) from stiff card and look through this to isolate an area that interests you. You can also frame the landscape with the thumbs and forefingers of both hands.

Acrylic is ideal for landscape painting because it allows you to work quickly and you don't have to hang around waiting for the canvas to dry – a boon in inclement weather. Pack the things you think you'll need, but keep it simple – you really don't want to carry lots of heavy gear. A canvas shoulder bag or small backpack will leave your hands free.

A lightweight sketching easel is handy, but you can manage without, certainly at the beginning. I like a box easel that holds all your kit and opens out into a sketching easel, but they're not cheap.

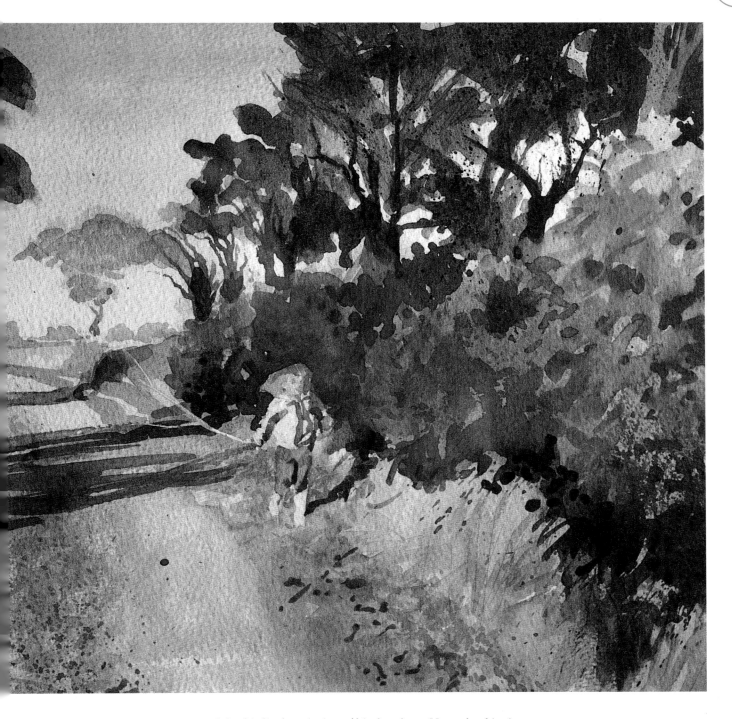

△In this lively painting of his daughter, Hannah, skipping along a country lane, the artist John Crawford Fraser used washes of transparent acrylic paint. In some areas the colours were blended wet in wet so that it is hard to see exactly where the dark green becomes ochre, for example. In others wet colour has been laid over dry paint and has dried with crisp, irregular edges which define the bulky, massed forms of the foliage.

PROJECTS

LANDSCAPE THROUGH THE SEASONS

The ideal landscape doesn't exist. It is as illusory as the ideal picnic spot – and you can waste a great deal of time looking for either. The good news is that you can find the subject of a landscape painting almost anywhere – in your garden, in the local park or in the lane at the back of the house. The subject doesn't have to be dramatic or picturesque; some of the more believable landscapes are those that have faults and flaws. A quarry or an apparently boring wall in a city can be just as stimulating as the most picturesque alpine view. And, what is more, you could paint the same scene every day and still find something different to say about it.

A constantly changing subject

The appearance of the landscape is modified by weather and light, by the seasons and the time of day. Sometimes we see it through veils of moisture-laden air, which softens forms and bleaches colours. At other times brilliant sunlight warms the darkest shadows and heightens colour.

The march of the seasons is reflected in the changing scene. In springtime drifts of pale green tint field and hedgerow, and sunlight is filtered by the sappy green of newly unfurled leaves. In summertime skies are blue, the sun is bright, hot and high in the sky, and colours are warm and intensely saturated. The autumn landscape is characterized by a rich palette of old golds and russets, with smoke hanging in misty skies. In wintertime the landscape is stark and bare, the weak sun hanging low on the horizon and casting long shadows.

A lane in Somerset

To illustrate the richness of the subject, and the way it is modified by light, by weather and by seasonal changes, I asked John Crawford Fraser to choose a location and make a series of four paintings over a five-month period.

He chose a barn and a clump of three trees in a hedgerow bordering a lane near his home in Somerset. He has painted there before – the pictures on pages 6 and 89 were both painted in the lane. 'It has some of the pastoral quality which attracted us to live in the area in the first place,' he says. 'And the barn was very representative of that.' He liked its skeletal qualities, and the way the geometry of the building contrasted with the organic forms of the trees.

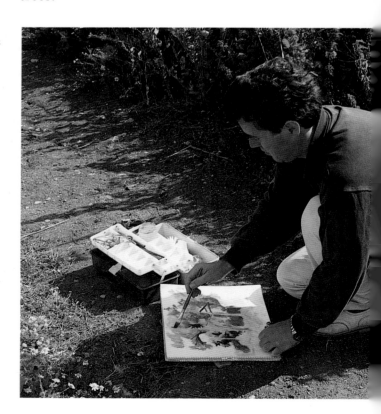

Mid-September

◁**1** *The subject is simple: three trees and an old barn with a lane behind, and behind that a low, flat landscape which hurtles off to the horizon. It was the end of summer and the trees were full and leafy.*

▽**2** *John worked with a watercolour pad, sketching the broad outlines in pencil, then developing the painting quickly, using only two colours – raw sienna and burnt umber.*

△**3** *The stark lines of the poles of the barn were strengthened by redrawing them in pencil.*

▽**4** *The warm ochry tones have a warm summery quality. The artist worked quickly, using thin washes and gestural marks combined with passages of thicker, unmixed paint from the tube. Spattering adds further texture to the foliage of the tree on the right-hand side and in the foreground.*

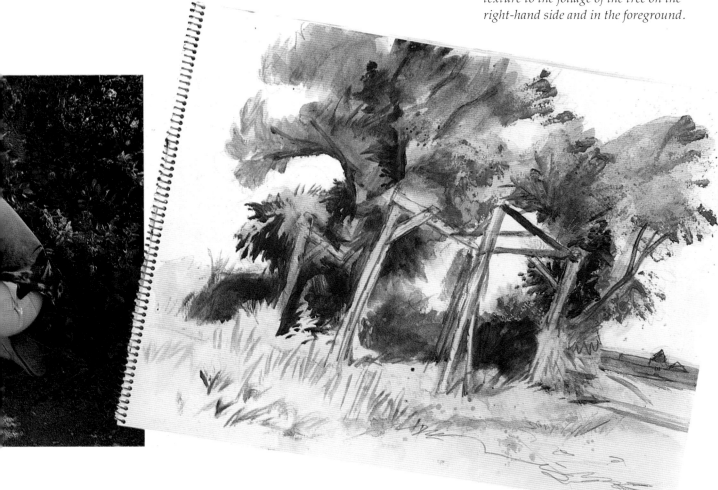

▽ Early October

This painting was done in early October, about a fortnight after the previous one. The support used here was muslin glued to cardboard with surplus paint. It was then primed with white but in places the reddish brown of the 'paint adhesive' peeks through, giving an underlying texture. The artist has opted for a square format, 17 × 17 inches (43 × 43cm) – a very compact, contained shape.

The trees still had their summer foliage, but as the weather was windy, the leaves were being tossed around in huge bunches and the clouds were scudding across the sky.

The paint was applied thinly so as not to obliterate the fine texture of the woven cotton. It is important to be responsive to the qualities of the support.

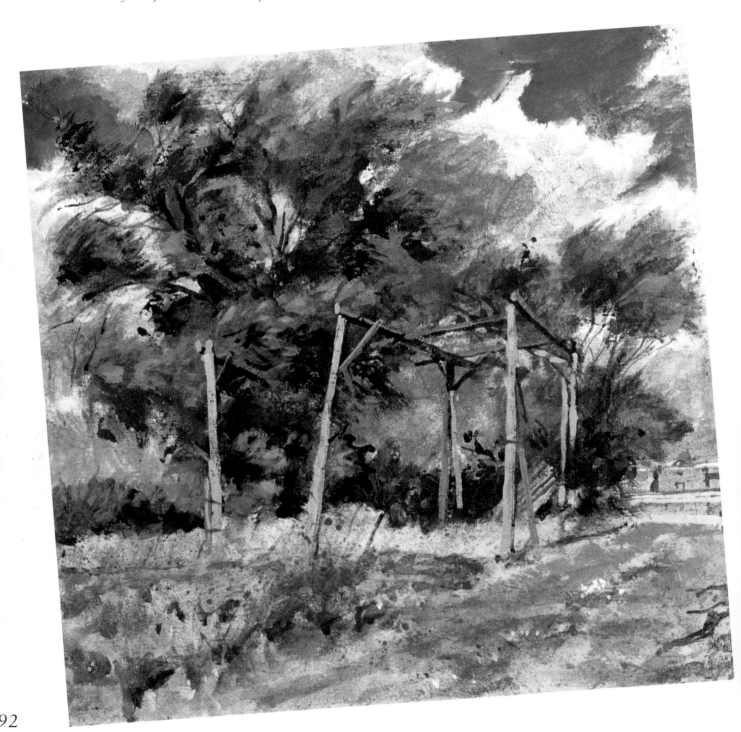

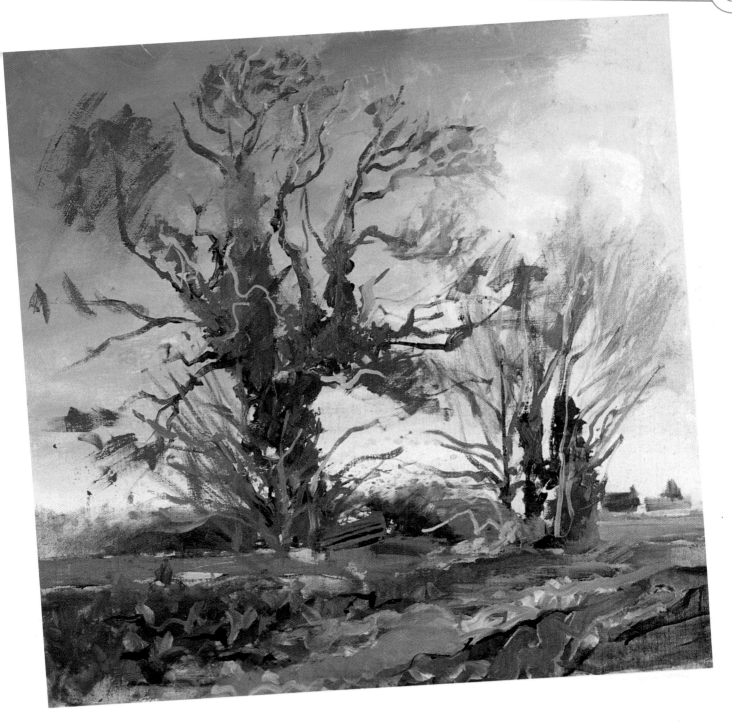

△ Early December

This painting is on linen canvas with an acrylic primer and is bigger than the other studies – 25 × 25 inches (63 × 63cm). It was made in early December after a gale which blew down the remains of the barn. When John found that the skeleton of the barn had blown away, he was pleased that he had decided to include the whole of the tree and had opted

for a square format, because the composition still worked, even without the linear structure of the barn. Painting conditions were difficult as the day was blustery and canvas and artist were constantly buffeted by great gusts of wind. The agitated brushstrokes and smeared paint in the treetops capture a sense of boughs and branches whipped by the wind. Underfoot the ground was wet and very, very muddy – you can see this in the loose brushwork in the foreground.

▷**January**

*On the day this was painted it was so
cold the artist had to wear gloves, and
it's not easy to paint like that. He used
a small support 9 × 9 inches (23 ×
23cm), made from plywood with a
roughly applied acrylic gesso ground.
The textured surface captured the
character of the hard, frozen ground.
The artist laid in the background in a
neutral greenish-grey, shading to pale
blue at the top. Against this muted,
frosty background the bare outlines of
the trees are picked out in raw umber
mixed with blue. Spattered colour
softens the foreground. The paint
surface 'went off' (began to get tacky)
very quickly. John dabbed at the
still-wet areas of paint with a rag,
creating the grainy, broken paint
surface which can be seen in places –
where the main trunk begins to
branch, for example, and in the
hedgerow.*

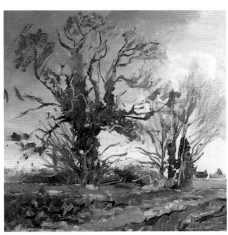

△ **Landscape through the seasons**
As this series of pictures shows, you can find absorbing subjects close to home. It is not necessary to find an ever-changing series of exotic locations – the most demanding and stimulating material is available within your home or just outside your back door. The greatest artists have returned to the same subject over and over again – Monet painted several series including his views of Rouen Cathedral at different times of day and his waterlily pictures. What you choose to paint is less important than how you see it and what you make of it.

95

INDEX